WITHDRAWN

THE REGIS SANTOS

THIRTY YEARS OF COLLECTING
1966-1996

by
Thomas J. Steele, S.J.
Barbe Awalt
and
Paul Rhetts

LPD Press
Albuquerque

1997

Book and cover design by Paul Rhetts and Barbe Awalt.
Photography by Paul Rhetts

Library of Congress Catalogue Card Number 97-70979

ISBN 0-9641542-4-2 (Hardcover)
ISBN 0-9641542-7-7 (Softcover)

Cover illustration: RU 300. Aurora Altar Screen. Altar Screen. 279.4 x 182.9 x 45.7. John Olivas & other Santeros del Norte. 1996

10 9 8 7 6 5 4 3 2 1

Contents

Foreword

During the production of this book, we began to think about other museum collections of New Mexican santos. We couldn't think of another museum that had cataloged its entire collection for public use. Of course, there are books that feature parts of collections or special exhibits taken from collections but not the entire collection to be used as a reference tool. That is a shame.

There are probably a few reasons for this oversight. The first is that many museums did not put a lot of importance, until recently, on New Mexican santos. The Native American collections were certainly sexier to the average museum visitor. The other reason may be that very few museums have, or know that they have, New Mexican santos in their permanent collections.

These reasons caused us about two years ago to start talking with Tom Steele about documenting the Regis University Collection of New Mexican Santos. This year seemed the best time to do the project. When we first started talking with Tom, he wanted to do a book that would have been a lot more academic than this finished product. We kept insisting that, at least from our standpoint, this was an opportunity for Tom to tell his story of what it is like to assemble a collection on a limited budget.

This was one of those times that a curator and teacher had an opportunity to tell the stories behind the collection. As this is a teaching collection, the reason the teacher chose individual pieces is in itself a lesson for students. The result is a very personal, at times funny, and thoughtful story of one person's love affair with one particular art form.

Santos have a profound effect on those who allow them to enter their lives. For each of us, the effect may be different, as different as each santo and each person or individual. Tom Steele's thirty years of collecting is more than just an obsession. It is rather a long search filled with deep understanding. This collection allows us to sample and share the rewards of that understanding.

Paul Rhetts & Barbe Awalt

Introduction: The History of the Regis University Collection

After my father died and my mother moved to a nursing home, my three sisters and my Aunt Clare broke up housekeeping at the family home in University City, a suburb of Saint Louis. When they portioned out various minor items of family memorabilia that were too good to throw away but just barely, various of them fell to each of us children.

Well, my mother was a saver. She saved everything, and in a very orderly way, so all four of us were confronted suddenly with numerous pieces of our biographies we'd totally or almost totally forgotten. One of the things I received in the mail came as a great surprise to me. It was a thin, dittoed, hand-colored booklet entitled "God's Saints" that must have dated from one of the early years of grade school since there was a saint for every letter of the alphabet. What a coincidence! I had colored each of the drawings with greater or lesser care, growing more and more careless as the project drew toward its close. Staying inside the lines has never been my strong suit. The saints were all depicted as little children, and a verse quatrain provided a each of them with a pious description; a quick survey of the implied theology revealed that miraculously paradoxical if not downright illogical combination of the heresy of Pelagianism (especially in being heavily authoritarian) and the polar-opposite heresy of Calvinism (at least in being morally rigorist) which was the staple of Catholic catechism before Vatican II.

I found the roster of subjects especially interesting. Since many of the Sisters of Mercy who taught at Christ the King Grade School were from Ireland, they might have been expected to toss in Columkille instead of Christopher and Patrick instead of Peter, but such was not the case. There was instead a remarkable convergence between the list in the circa-1940 booklet and the list of about ninety saints that I had assembled for the 1974 and 1994 editions of *Santos and Saints: The Religious Folk Art of Hispanic New Mexico*, holy males and holy females whom the New Mexican santeros depicted during the eighteenth and nineteenth centuries. Not until "O is for Oswald" did the lists part company. In New Mexico only San Onofre began with an "O," and he would be Humphrey in the Anglo world. The New Mexican santo world offered no alternatives for saints Quentin, William (the letter W doesn't occur in Spanish), and Zephyrine, though San Vicente Ferrer and Santa Verónica could have mounted a strong challenge to the ever-popular Valentine.[1]

Even without my remembering it consciously, that little booklet probably exercised an influence on my adult career. I had always been interested in religion and in art — once I got beyond the just-stay-within-the-lines stage of development in both areas — and so when I moved to Albuquerque in 1965 to begin work on a doctorate in English, the santos very rapidly caught my attention. My very first mentor in studying them was a parishioner at the Jesuit parish, don Gilberto Espinosa, who had assembled a fine collection of santos through the years. In the mid-1930s, he had been the author of the first substantial set of articles on the subject, articles which focused the reader's attention on the santos and the holy personages they portrayed as a major component in the spiritual lives of the

[1] Saint Valentine is not only the traditional patron of lovers, he is also, I have determined, the patron of golfers. He was martyred by being shot with arrows, but no matter how many arrows his executioners shot into him, he was always ready for another nine holes.

The "K" saint was Katherine of Siena, spelled of course with a C in Spanish. Other saints with spelling changes were Elizabeth-Isabel, George-Jorge, Helen-Elena, and Stanislaus-Estanislao; Francis Xavier was the "X" saint. The "Y" saint was "You / And a saint you must be; / Just copy the saints here / From A down to Z."

Hispanic people of New Mexico — their faith lives, their prayer lives, and their morality. If don Gilberto bent the twig of my nascent interest away from art criticism and art history and turned it instead toward a "socio-religious phenomenology" of santos, he was doubtless aided to some degree by my early exposure to the dittoed draftsmanship and crayola colors of "God's Saints."

The period of my doctoral studies provided me with very little disposable income, but I was able to get a few santos in the roundabout low-budget ways I will shortly describe. But when I won a National Endowment for the Arts and Humanities fellowship for the summer of 1969, I put about a third of the stipend into santos and was definitely hooked on collecting. At that time an aficionado literally had a choice between getting a nice santo and going out to dinner eight or ten times.

The Mexico City Olympics of 1968 had started a ripple in Hispanic art prices that sent them up never to come down, so the inexpensive option of "feast the eyes or feast the tummy" vanished not to return. The price escalation meant that the little collection I had assembled — the first sixty or so pieces on the list — were too valuable for my vow of poverty to be comfortable with, and so I donated it to the Regis Jesuit Community in the mid-1970s. The up sides of my humble generosity were first that I got to keep the collection in my room where it had been and, secondly, that if I found a santo that seemed like a good buy and a nice addition to what we already had, I could without much embarrassment ask the Jesuit Community for the money. I forget what the down side was.

Then in 1989, the Jesuits' Missouri Province, the Regis Jesuit Community, Regis University, and I entered into a complex arrangement whereby the santos — by this time 128 pieces — became the property of the University, which committed itself to financing new acquisitions and — dear to my heart — putting the collection on display. Of course many of the pieces had "gone public" briefly on the Regis campus and had gone on tour to places like the Foothills Art Center in Golden, the Arvada Center for the Arts, the Denver Public Library, and St. Thomas Seminary. But finally they really had a home to live in, a glass house in the Dayton Memorial Library, a space that I was quite satisfied with, immensely proud of, and very grateful to the University for. It generated some excellent publicity for the school, above all a feature article by Joanne Ditmer in the *Denver Post* "Magazine" for 22 January 1995.

The Library was emptied for a total renovation and expansion after the 1995-96 academic year, then it reopened in 1997 with the Regis Collection of New Mexico Santos on display in a bigger and better space that featured a much more high-tech security system — not a glass wall but an electronic curtain that permits the santos to make their own space and allows the viewer to come psychologically much closer to them. If, Dear Reader — as a nineteenth-century novelist would say — you ever find yourself in exotic Northwest Denver, please drop in, take a look, and see the results of my santo-collecting, which began as a mere passing interest and became by turns a hobby, then an avocation, and finally the epicenter of a whole second career. And the up-side is that it's one of the more socioculturally-acceptable forms of obsessive-compulsive behavior.

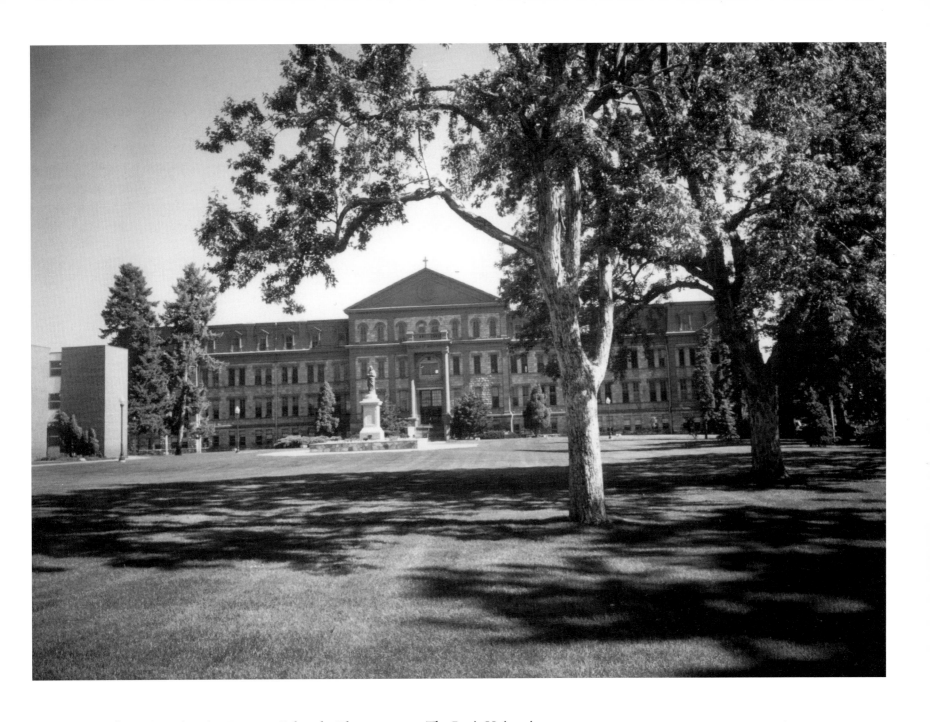

Old Main Hall, Regis University, Denver, Colorado. Photo courtesy The Regis University.

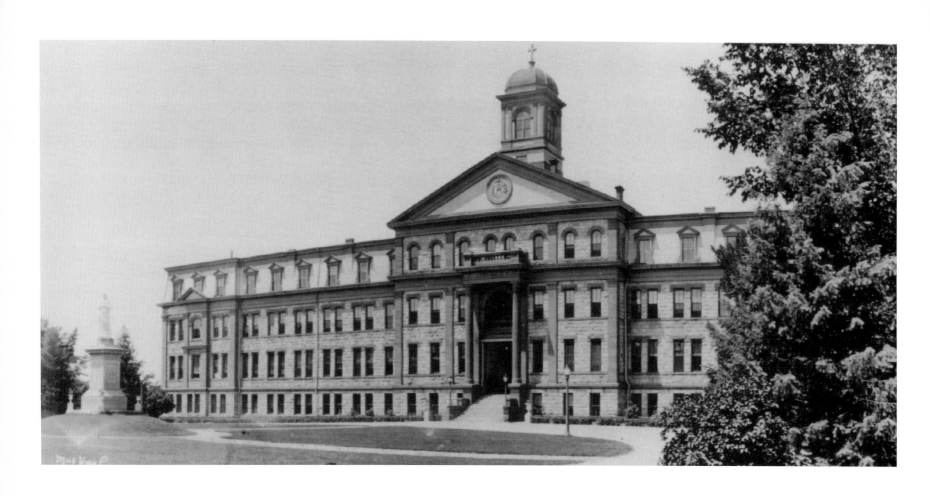

Old Main Hall, Regis University, circa 1940. Photo courtesy The Regis University.

Regis University: History, Mission, Jesuit Character

by the Very Reverend John J. Callahan, S.J.
Rector of the Regis University Jesuit Community

The Society of Jesus is a religious order of men within the Roman Catholic Church. Founded in 1540 by St. Ignatius Loyola, the Jesuits, as they became known, have concentrated on educational, missionary, and pastoral work for over 450 years.

In 1860, Garibaldi conquered the Kingdom of Naples during his struggle to unify Italy under the leadership of King Victor Emmanuel of Savoy. Since the Jesuits had backed the inept Bourbon King of Naples, Garibaldi expelled them all. Hearing of this sudden supply of available clerical manpower, Bishop Jean Baptiste Lamy of Santa Fe appealed to the Roman Curia for their help in staffing his sprawling frontier diocese. Thus it was that five Jesuits, two brothers and three priests, soon found themselves trekking across the Santa Fe Trail toward the Rio Grande River.

From their base at a church in Albuquerque, the Jesuits branched out in various directions and into various ministries. They preached parish missions — the Catholic equivalent of revivals in Protestant churches; they took over the Conejos, Pueblo, and Trinidad parishes in the new Vicariate of Colorado; and they acquired a printing press. When the Rio Grande menaced the old Albuquerque Plaza during the flood of 1874, the Jesuits became

so worried about their huge investment in printing equipment that they moved it to Las Vegas, at the time the leading boom town of the Front Range of the Rocky Mountains, and there they began the weekly Spanish-language newspaper *Revista Católica*.

The Jesuits had long planned to open a *colegio* — today we might describe it as a junior high, high school, and junior college rolled into one — but had never quite managed to do so until prosperous Las Vegas provided adequate backing. The College of Las Vegas opened in November 1877 and succeeded from the start. Soon, however, there were major troubles. First, the Territorial governor prevented the legislature from chartering the fledgling school as a tax-exempt institution which could grant diplomas and degrees. Then the Jesuits wrangled so stubbornly with the local pastor and his powerful friend Archbishop Jean Baptiste Salpointe that the bishop eventually suspended them. The Jesuits in New Mexico thus seemed to go out of their way to demonstrate the Jesuit stereotype: men who get kicked out of countries, who establish schools wherever they go, and who get into trouble with local church authorities.

Since their arrival, the Jesuits' drift had consistently been northward, up across the

New Mexican border into Colorado. In 1884 they had started a little *colegio* a dozen or so miles west of Denver that ran concurrently with the larger school in Las Vegas. In 1887 they laid the cornerstone for Main Hall on the present northwest Denver campus. In the late summer of 1888 both schools abandoned their original locations and moved in together, forming Sacred Heart College, Denver.

In 1921, chronically embarrassed by the nickname "The Shack," which the students had derived from the initials S.H.C., as well as by inventive football cheers and comments concerning the Sacred Heart Dance, the fathers took advantage of the reorganization of the Jesuits in Amerca which followed World War I and changed the name of the school to Regis College in honor of the Jesuit saint John Francis Regis (1597-1640), who had worked in the mountains of southern France and who had died in much the same way as had the beloved first Jesuit to die in New Mexico, Father Raffaele Bianchi: each man heard too many confessions in a too-cold church and died of pneumonia. In 1991, to mark its vastly increased size, geographical scope, and organizational complexity, Regis College became Regis University.

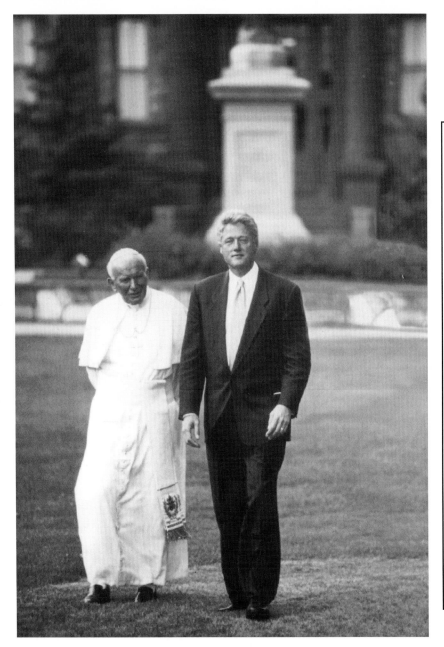

His Holiness Pope John Paul II and President William Jefferson Clinton walking together in front of the Statue of the Sacred Heart and Old Main Hall, Regis University, August 12, 1993. Photo courtesy The Regis University.

REGIS MISSION STATEMENT

Regis University educates men and women of all ages to take leadership roles and to make a positive impact in a changing society. Standing within the Catholic and United States traditions, we are inspired by the particular Jesuit vision of Ignatius Loyola. This vision challenges us to attain the inner freedom to make intelligent decisions.

We seek to provide value-centered undergraduate and graduate eduction as well as to strengthen commitment to community service. We nurture the life of the mind and the pursuit of truth within an environment conducive to effective teaching, learning, and personal development. Consistent with Judeo-Christian principles, we apply knowledge to human needs and seek to preserve the best of the human heritage. We encourage the continual search for truth, values, and a just existence.

Throughout this process, we examine and attempt to answer the question "How ought we to live?"

As a consequence of Ignatius Loyola's vision, particularly as reflected in his Spiritual Exercises, we encourage all members of the Regis community to learn proficiently, think logically and critically, identify and choose personal standards of value, and be socially responsible. We further encourage the development of skills and leadership abilities necessary for distinguished professional work and contributions to the improvement and transformation of society.

—Adopted by the Board of Trustees, 1991

University: American, Catholic, and Jesuit

Any university worthy of the name is a community of adults who seek, discover, preserve, and communicate what is true, good, and beautiful. Of course, Americans would probably add "workable" and Regis University stands within the American system of education. Chartered by the State of Colorado in 1889, it has been coed since 1968. It not only complies with all local, state, and federal nondiscrimination laws and regulations in providing educational services, it does so gladly because it wishes to reflect the pluralism of contemporary American society.

Regis University is Catholic. It is a learning community where teachers and students of many different beliefs search together for a transcendent meaning in human life and human society, thereby continuing the age-old dialogue between faith and culture. Christian in inspiration and grounded in an institutional fidelity to the Christian message as proclaimed by Catholic teaching, it remains ever faithful to a centuries-old intellectual tradition that asserts the intrinsic validity of human reason and asserts that faith and intellect illuminate each other. Regis is pledged to academic freedom and freedom of conscience within a framework of civility and mutual respect: each individual respecting the Catholic identity of the University which he or she may or may not share, and the University respecting the free conscience of each individual.

Regis University is Jesuit. It grows out of a spirituality that Saint Ignatius Loyola, the founder of the Society of Jesus, codified in *The Spiritual Exercises*. A central part of his worldview is his vision of the fundamental goodness of a world God the Father so loved that he sent his only-begotten Son to redeem it by living out a love that is far stronger than human weakness and evil. Being a child of the Renaissance as well as a child of God, Ignatius saw clearly the goodness that might be found even in the pre-Christian cultures of Greece and Rome; and as a Jesuit school, Regis therefore stresses a humanism of rigorous and probing inquiry, creative imagination, and discerning and critical reflection on the movements of the human heart, seeing to it that the search for meaning and values is intellectually grounded and respectable even while remaining idealistic and altruistic. The Jesuit educational tradition, moreover, commits Regis students to academic excellence, to critical thinking leading to valid moral decisions, and to a love of the world that echoes God's own in striving, as partners of the creating and redeeming Lord, to make God's world more just and more holy, more human and more

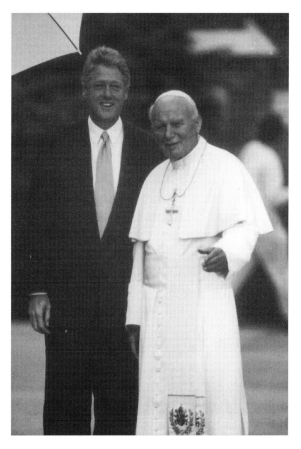

divine. The worthy graduate of Regis University will therefore be a man or woman *for others* — not a selfish individualist but a person who grows through creative interpersonal encounters and the service of others.

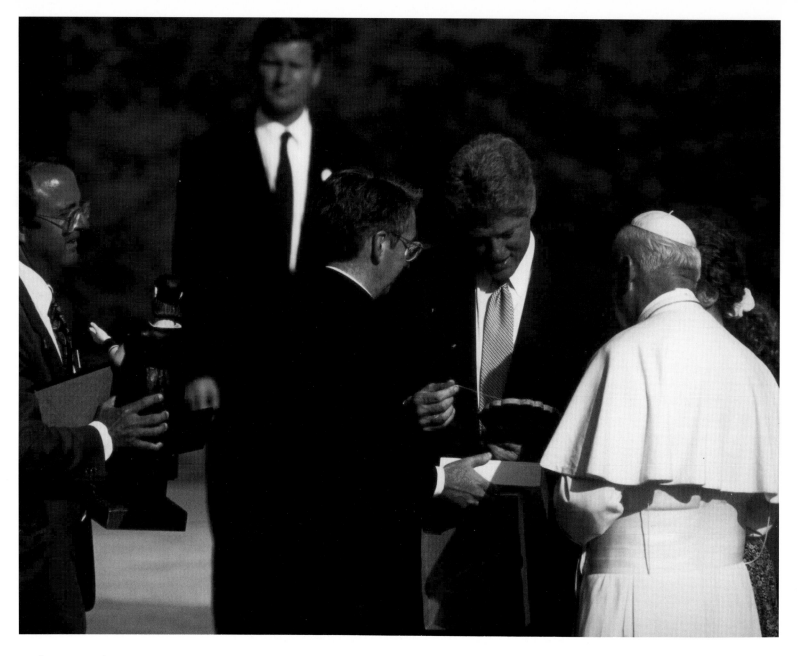

In the name of Regis University, Father Michael J. Sheeran, S.J., gave a San Ignacio de Loyola retablo panel painting by Charlie Carrillo to President William Jefferson Clinton and a San Ignacio de Loyola bulto (statue) to His Holiness Pope John Paul II during their visit together at Regis University, August 12, 1993 (see pages 27-29). Photo courtesy The Regis University.

The Idea of a Teaching Collection

My late friend Edwin Bewley of Llano Quemado remarked to me one evening, as we examined his many wonderful santos, that he defined a collection of santos as twelve or more. The whole quotation, as best I can recall it, was this fine one-liner, delivered apropos of a particular panel painting: "Every collection — and I define a santo collection as twelve or more — has a fake. This is mine." At any rate, not long after Edwin and I spoke, my santos reached a dozen in number and became, in Edwin's eyes at least, an official collection. Since that time if not even before, its character, its *raison d`etre*, has been clear to me, and not so much because of what *it* was as because of what *I* was and still am. It's an extension of myself, and since I am a teacher, it is a teaching collection.

Consequently, the Regis Collection of New Mexican Santos emphasizes instruction. It has more of a tilt toward sociology of religion than toward studio art or toward art history and art criticism. It is more concerned with the characteristic and ordinary than with the unique. And it welcomes pieces that for various sorts of reasons should not be displayed but which ought to be available to qualified scholars for serious research.

The Regis Collection is, in other words, a "working" collection. It has a job to do which makes it at home within the context of the century-old Regis University task, and the purpose of the collection provides me, its curator, with a set of goals toward which to point it.

Now I think I appreciate as well as the next person the artistry and aesthetic beauty found in the works of the classical santero masters of the 1830s and in the works of the contemporary masters, many of whom are my personal friends. But in some ways the acquisition of a composite oddity such as RU140 — body by Rafael Aragon, head by José Benito Ortega, Christ Child by José de Gracia Gonzales — satisfies my compulsive pedagogy as much as getting an integral Rafael Aragon santo or a piece by one of the contemporary great santeras or santeros would satisfy the aims of a museum curator or a connoisseur. No connoisseur would have such a composite as RU140 in his or her collection for a minute, and I doubt that many museums would knowingly acquire such a monstrosity.

Even further along the same line, I knowingly purchased a fake — RU253, a little retablo seemingly made with intent to defraud, loosely copied from the photo of RU71 on the cover of the 1982 edition of *Santos and Saints*, and palmed off on a Canyon Road dealer who resold it. I confess that the Albuquerque Museum has a known fake in its permanent display, but it was a gift. I spent money for *our* genuine fake.

Why do I find a composite or a fake appealing when other aficionados of the santos would find them appalling? Well, when I'm looking through the viewfinder of my camera, I tell myself what I'll say when I show this slide to a classroom full of students, and I approach santos in much the same way. When I look at a santo that I'm thinking of buying for the University collection, I talk silently to myself about what it exemplifies, about how it demonstrates something that's true of the santos, true of New Mexico, true of Catholicism, true of the human search for the divine and of God's search for our love; and if I think that what I hear myself saying would, over a period of time, repay the cost, I buy the santo. Similarly, if some generous person donates a piece to the Regis Collection, I find that the enthusiasm and sincerity of my expression of gratitude depends (more at times than I want it to) on the teaching value of the item rather than on either the market value or the aesthetic quality.

Because the santos are so reminiscent of the geography and the Hispanic culture of New Mexico, where Regis came into being a hundred and twenty years ago, and because the santos are so deep-rooted in the Catholic

tradition of Spanish and Mexican Catholicism, Regis University is convinced of their abiding value. In New Mexico's Hispanic towns and Indian pueblos, santos have been part of the Catholic faith and Catholic practices for centuries because they exemplify the incarnational, sacramental aspect of Catholic Christianity. The representations of the holy persons present at the passion and death of Jesus stand at the center of the whole body of santos, and these statues of the suffering Jesus the Nazarene, these gripping crucifixes, these appealing figures of the Dolorosa are some of the enduring forms of the passion and death of the Lord in parallel with scriptural narrative and sacramental ritual: enduring forms which insure that the central event of Christianity will never be forgotten, will never be absent from the world Christ redeemed.

Finally, a connoisseur or a museum curator will most often display each santo in its own space, separated from the santos to either side by a "no-santo's-land" of neutral, off-white wall. By contrast, the Regis display suggests the original environment in and for which the santos were made; it resembles a family altar, a *morada oratorio*, a village chapel that's not controlled by the pastor of the town church, with santos of various sorts crowded together on the wall and on the table-top. I try to group the Regis santos in such a manner that they seem to form a community among themselves.

In summary, then, the Regis University Collection of New Mexican Santos is not a connoisseur's collection because it does not place primary emphasis on aesthetic excellence. Secondly, it is not a museum collection; like a museum, Regis University does indeed collect, preserve, and interpret santos, but it places a relatively low priority on collection and preservation and such a high priority on interpretation that the adjective "teaching" is the central part of the collection's central purpose.

Significant Santos from the Regis Collection

GETTING STARTED

Note: Bold catalogue numbers indicate that a color plate can be found in that section.

During the summer of 1966, I was looking for a picture frame in Pauline's on North Fourth, at that time located where Corrales Road ended at Fourth Street, before it continued east to the Interstate. I don't remember any longer what it was I wanted to frame, but as I was looking through Pauline's offerings, I came across a piece of masonite with an old, dirty, faded, torn, creased canvas glued to it, a canvas that bore a dim image of a black-clad female figure in a dull brown background. I was intrigued indeed, but Pauline wanted twelve dollars for the item, and that was far too much to spend on something I didn't understand at all. In those days I was on a pretty tight leash financially.

But the next week, I went up to Santa Fe with some of the other younger Jesuits, and we visited the Palace of the Governors. The chapel was then where the giftshop and bookstore is now, on the east end along Washington Street; and at the back of the chapel, just east of the door on the south end, there was an oil painting of a black-clad female figure in a dull dark background. It was identified as an early-eighteenth-century Mexican oil painting.[2] Now if this is worth

putting in a museum display, I said to myself, that painting in the shop on North Fourth is worth twelve dollars.

So I went back to the shop in Albuquerque a few days later, talked Pauline down to ten dollars, and took the painting over to Gloria

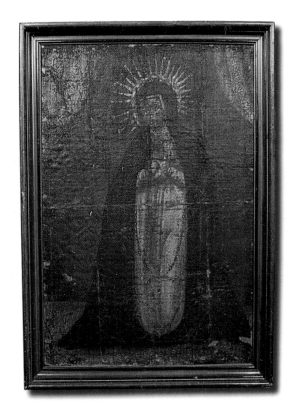

RU 051. Nuestra Señora de la Soledad. Oil on canvas. 66 x 45. Mexico. 1725-50.

and Bud Sullivan's to see if I could get any help with the subject and ask them for a guess as to the dating. After I got it home, I used an industrial-strength tank vacuum cleaner on it, carefully holding the inch-and-a-half hose just a trifle above the surface and moving it back and forth to get rid of a lot of accumulated dust, and next I washed the painting gently with turpentine, brushing it on and blotting it off with a clean rag, and finally I stabilized it with damar varnish — a mistake because the glossiness became a problem to the viewer. But by this time it clearly enough had taken the shape of a woman with a halo, dressed as a nun, standing between two tied-back curtains with her hands folded in prayer and a rosary draped over her forearms.

Then I asked the help of Father Pierre Landry, who had been around the parish off and on for many years, and he took me over to Gilberto and Catherine Espinosa's house. In the mid-`30s, don Gilberto had written the first several articles about the santos that took the viewpoint that I have maintained ever since: the santos as part of the Hispanic people's religious life — their faith-life, their ceremonial cycle, their value-system. Gilberto got the age of the painting right but, identifying the subject as a nun, he guessed it might be Sor Juana Inés de la Cruz (1651-

[2] It was A.5.54.41, Nuestra Señora del Rosario, 1 vara x ⅔ vara (32+" x 22"), Museum of International Folk Art, Santa Fe, New Mexico.

95), the brilliant Mexican poet of the late seventeenth century. And he sent me to E. Boyd.

E — "The Fastest Attribution in the West" — reached and delivered her conclusion in five seconds or less: Mexican, second quarter of the eighteenth century, Nuestra Señora de la Soledad. Our Lady of Solitude was Mary's title between the Death and the Resurrection and again between the Ascension and her own death. She was imagined to have lived like a cloistered nun and to have been the archetypal crone, a woman bereft of all the men in her life such as father, brothers, husband, and sons — and consequently a figure of very great power.

By that time I had a frame on the Mexican oil and kept it hung in my room, and the more I lived with it the better I got to like it. I used to remark that it was "psychological Air-Wick" — it took all the tension out of the atmosphere. Then one evening I described it to some friends, Paul and Jane Choc, who wanted to see it — and then to borrow it — and finally to purchase it. I let them buy it from me because by that time I had become interested in New Mexican santos. We agreed on a price of fifty dollars.

Don Gilberto put me in touch with a friend of his from the South Valley in Albuquerque, L.A. Rice, who was a "picker," a person with contacts in the small villages who would purchase just about anything that people wanted to sell and resell it for a profit to some or another of his contacts among the collectors. I phoned him and met him at his house off Blake Road. He had a Santa Rosalía by José Aragon which is presently **RU001**, the first item to enter what has become the Regis University Collection

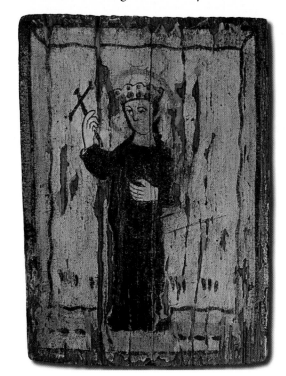

RU 001. Santa Rosalía. Retablo. 28 x 21. José Aragon. 1820-35.

of New Mexican Santos; it also served as the cover illustration of the original 1974 edition of *Santos and Saints*. Rice — much against my will and best judgment, which was totally uneducated — forced me to take a tin-and-glass cross, for which he probably got me to pay an extra five or ten dollars. I did not know what a favor he was doing me. I hated the item, showed it to nobody, was embarrassed at owning it. The design was largely carried by combed reverse-glass paint. As best I can recollect it, that cross would now be worth maybe twelve to fourteen hundred dollars. The next time I got a little money together — that's the next story — I threw in the cross when Eleanor Bedell allowed me about five or ten dollars for it toward the price of a purchase.

The Santa Rosalía I cleaned myself with acetone; it was not in very bad shape at all. I kept hoping that there might be some lettering in the cartouche at the center bottom, but neither the naked eye nor magnifying glasses nor ultraviolet has ever shown anything. Except for the missing skull, it remains a classic José Aragon panel of Santa Rosalía, hermitess, penitent, and protector against plague. And since I've owned it, I haven't had the plague even once.

And after enjoying the Soledad for several years, the Chocs generously donated it back, so it is now **RU051**.

THE SECOND STEP

Gloria Sullivan's husband Bud worked at the time for Chrysler's finance wing, and they had repossessed a car with a .22 magnum rifle with a broken stock in the trunk. At the time — April 1968, it must have been — I had finished my dissertation and taken it the typist, so I volunteered to

RU 002. Nuestra Señora de los Dolores. Retablo. 31x 23. Antonio Molleno. 1820-40.

price a new stock and make the changeover. I found the cost of the stock so outrageous — far more than the "works" were worth — that I decided to try to handmake one. I found a two-by-four of birdseye maple — an unplaned one, so it was a full two by a full four inches — that was left over from building a portable face-the-people post-Vatican-II altar, and I went to work at the workbench in the rectory garage where the telephone secretary could find me when my typist had any questions to ask.

The work went along pretty well; the one task for which I needed professional help was drilling a fairly large hole up from the bottom for a single bolt that held the barrel to the stock; it had to be precise enough to hold the ensemble together with no give or wobble at all. For help I turned to Mr. Tom Montoya, the man in charge of the physical plant at the church and grade school and a man of great practical knowledge, and he took me over to McBride's Welding on Second Street a short way north of Lomas. They did our welding work, were good friends of Father Landry, and did my little task on a big drill press in about two minutes, did it perfectly, and did it for free. What a wonderful arrangement!

This contact with my project made Mr. Montoya fall in love with the rifle, and so

RU 052. Nuestra Señora de los Dolores. Bulto. 61 x 26 x 20. Molleno/Follower of. 1800-40.

he also helped me pick out the right type of clear varnish to finish the stock. Once I got the whole item together I bought some bullets, noticing when I did so that the magnums cost five or six times as much as

RU 195. Santa Gertrudis la Magna. Retablo. 80 x 47. Antonio Molleno. 1835-50.

regular .22s. Then I took the gun out to shoot it — only to find that the firing pin was broken; so I handmade one from a piece of steel with hacksaw and a file. It worked! The gun shot nicely and felt extremely good in my hands.

I talked matters over with Bud Sullivan, offering to free him from a gun that would be expensive for his sons to shoot by trading him my nice little single-shot .22 that would take longer to load and that fired far cheaper bullets. He opted for that, so the magnum with the handmade stock was mine.

Once again, I didn't keep my prize for long. I used it for target practice a few times with the Sullivan kids and a few times by myself, but it seemed too expensive to me. And so when Mr. Montoya asked me about buying the gun, I entertained his offer rather gladly: again, the price was fifty dollars. And as with the eighteenth-century Mexican oil painting money, I knew what to do with it: get a New Mexican santo. So I was off to Santa Fe, to Eleanor Bedell's shop on Canyon Road, and with the help of most of the fifty and that ugly cross that L.A. Rice had stuck me with, I acquired the second Regis University santo, Antonio Molleno's Nuestra Señora de los Dolores (**RU002**). By the time I'd cleaned it and studied up on it, I now realize, I was pretty well hooked as a collector of santos.

A few years later we acquired a fairly large, very fine, and rather rare hollow-frame bulto (**RU052**) of the same subject as the retablo, Our Lady of Sorrows. The statue seems at present to belong to the Laguna-Molleno School, but since L.A. Rice had acquired it in the Belén area, it may possibly turn out to be part of the Rio Abajo style group presently under study. The tin *resplandor* (halo) and sword are my doing, but the holes for them were already present. The bird-fetish necklace was lost on the Regis College campus, and nobody ever claimed it, so there it sits.

The huge Molleno panel of Santa Gertrudis (**RU195**) came from the Frank Visqueney bequest to Casa Angelica in the South Valley of Albuquerque. It was in sad shape, very dirty, streaked with house paint, and deeply gouged on the surface — not out of malice, so far as I could tell, but out of sheer carelessness. I cleaned it and rough-shaped four pieces of wood to replace the missing frame, then Charlie Carrillo painted the frame and inpainted the Santa Gertrudis figure enough to enable the viewer to make out the design. The panel probably makes a set with several other Molleno panels of the same very large size that may be seen in plates 47, 48, 50, and 52 of Larry Frank's *New Kingdom of the Saints*.

PUBLISHING

As my collecting went forward, I began to read up on what I'd acquired, and as I did so I began to think I could add a few insights to what had been written because of my peculiar vantage points and abilities: my training in theology, my "insider" experience of the Catholic Church, my long-standing interest in art, some skills at reading and interpreting literary symbols that might transfer into art, and especially the intense immersion in the santero world that the 1969 summer grant afforded me. I began to do a little lecturing around Denver, taught some minority-studies classes at Regis in the early '70s, and published some articles.

Between those articles and the rather extensive writeup of the 1969 National Endowment project, I had produced a pretty substantial body of information, but I didn't perceive any unity to it until I began writing the article that eventually became Chapter Three of the 1974 and 1982 editions of *Santos and Saints* and that still exists in revised and improved condition as Chapter Five of the 1994 edition. I made a lucky guess that the Passion Play was the connection between the penitential Brotherhood of Our Father Jesus the Nazarene on the one hand and the santos on the other; this final article served as a catalyst or seed crystal that drew most of my

previous writing into place around it and generated a book. Once again, this breakthrough issued from some help my friends don Gilberto and doña Catherine Espinosa gave me, for they introduced me to Mr. Paul Torres of Tomé, who took me up to the top of the Cerro de Tomé and described to me the passion play performances that the people of the parish had staged in and around the plaza every Holy Week up to the mid-1950s and on the Cerro for several years thereafter.[3] Moreover, Calvin Horn Publisher had released don Gilberto's *Heroes, Hexes, and Haunted Halls* (1972), and so I approached them to see if they were interested in looking at my manuscript; they were indeed interested, and George Fitzpatrick, who had edited *New Mexico Magazine* for years, became my editor and improved the book immensely.

[3] Mr. Torres also alerted me to the existence of a home movie taken by Mr. Ben Otero of the nearby town of Los Lunas, and when, with the help of Archbishop Robert F. Sánchez and of Father Jim Moore, I had been able to borrow and copy the movie, show it in the Tomé church, and borrow the scenario and the sermon précis that Mr. Fred Landavazo had written in the later 1940s, I was off to a running start toward another book, *Holy Week in Tomé: A New Mexico Passion Play.*

The first edition of *Santos and Saints* appeared in 1974 with José Aragon's Santa Rosalía (RU001; see page 18) on the cover, and that first edition sold out in a little over a year. In 1982, when the time seemed ripe for a reprint, Calvin Horn Publisher had become inactive, so Ancient City Press of Santa Fe took the book over. I corrected a

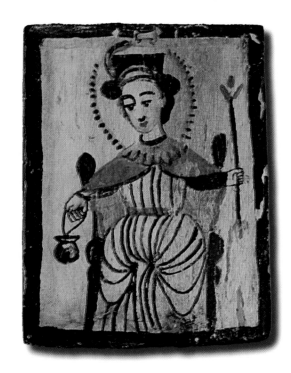

RU 071. Santo Niño de Atocha. Retablo. 17.5 x 13.8. Rafael Aragon/School of. 1820-70.

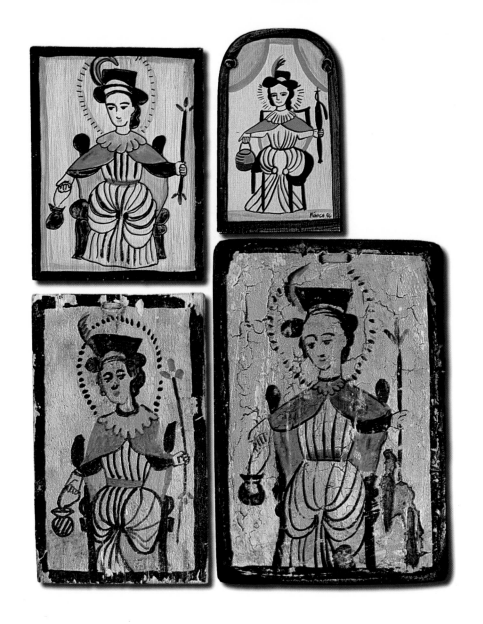

few of the most egregious typographical errors, added a two-page "Update" that alerted the reader to some important books and articles that had appeared in the intervening eight years, and then to make the second edition look more different than perhaps it really was, we put Rafael Aragon's winsome Santo Niño de Atocha (**RU071**) on the cover, a small retablo from Bill Dutton's Rare Things shop in Sena Plaza and the first Rafael Aragon santo in the Regis Collection. This same figure appears on the totally rewritten 1994 version.

A good color photo of a handsome santo tends to invite santeros to make copies, and the Regis Collection includes several. The first one (**RU087**) was a gift from Irene Martínez Yates, to whom I was introduced by a mutual friend, a student in one of my UNM courses, in Irene's shop in Old Town Albuquerque. When I saw her copy I said immediately, "I'll have to buy that from you," to which she replied immediately, "I'll have to give that to you," as indeed she did. The copy by Mónica Sosaya Halford (**RU115**), which could actually have been drawn from another of Rafael Aragon's many panels of the same subject, I saw on sale at the gift shop in the Antonio Severino Martínez Hacienda when I took a class of Colorado College students there in May 1987. And Al

Florence gave me his copy (**RU284**) when I'd given him a copy of the 1994 rewrite.

The final version of the little Niño de Atocha (**RU253**) seems to have been created deliberately as a fake. It was sold from a Canyon Road shop, apparently in all good faith, to a buyer who made the mistake of staining the back and who therefore, when he discovered that it was inauthentic, could not demand his money from the seller. A mutual friend put the buyer and me in touch, and I offered him what I thought it was worth to the Regis University Collection to be able to exhibit the Rafael Aragon original side by side with the fake created from it a century and a half later. And talk about instructive for the viewer!

While I'm on the topic, we have been able to acquire some other retablos by Rafael Aragon, often considered to be as good as best of the classic santeros. In 1992, a handsome Sacred Heart (**RU160**) went up for sale at Throckmorton's on the Plaza, and it was further remarkable for its rich numerological symbolism of threes and fives for the three nails and the five wounds. Then there was the San Acacio (**RU180**), perhaps by a follower of Rafael himself, with a few interesting departures from the standard iconography. The San Miguel (**RU240**) could have been by José Aragon (no known

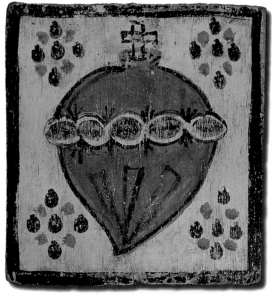

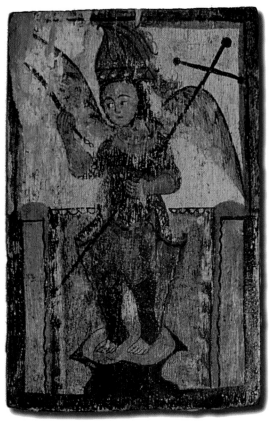

Clockwise from top left:
RU 160. Sagrado Corazón. Retablo. 19.4 x 18.9. Rafael Aragon. 1820-62.
RU 240. San Miguel Arcángel. Retablo. 22.5 x 15.1. Rafael Aragon/School of. 1830-60.
RU 180. San Acacio. Retablo. 20.9 x 16. Rafael Aragon/Follower of. 1830-60.

RU 144. San Ignacio de Loyola. Retablo. 33.3 x 25. Rafael Aragon. 1820-65.

relation) rather than Rafael. Since several crucial areas of the panel were missing and others badly restored, the identity of the artist was anyone's guess.

The final Rafael Aragon item is surely the dearest to my heart. Not only is it a relatively large panel done in the finest style of a master santero of the classic period, but it represents Saint Ignatius Loyola — San Ignacio de Loyola (**RU144**). Acquiring this broke the budget for an entire year; I have never for a moment regretted it. I had been looking for a quarter of a century for a superb Ignacio without ever having one come up for sale, and when the moment arrived in 1991 and the money was there, I did not hesitate, all the more so because 1991 was the quincentenary of his birth and because Ignatius is extremely special to me and to Regis — indeed, to everyone and everything Jesuit.

Iñigo López de Loyola y Oñaz was born in 1491, a younger son of minor nobility in the Basque country of northern Spain. His commitment to the ideals of the courtier and soldier earned him grievous battle-wounds of both legs, but during his lengthy convalescence he read lives of Christ and of the saints and completely changed the focus of his life. Giving himself to prayer, pilgrimage, solitude, and asceticism, he fell

into many excesses of penance, but after much trial and error he developed a system of meditation and spiritual direction embodied in his *Spiritual Exercises*. Since he had no credentials, his attempts to help people draw closer to God got him into trouble with the Inquisition, so he decided to turn to formal studies. While he worked toward his master's degree at the University of Paris, he began to gather companions who became the nucleus of the Compañía de Jesús, the Society of Jesus, of which he became the first superior-general. He died in 1556.

Ignacio was important in New Mexico for several reasons. He was a Spaniard and the founder of a major religious order, and he was thought to protect against witchcraft; both Hispanics and Indians treasured as talismans medals that depicted him. And finally, the Brothers of Our Father Jesus the Nazarene credited him with being their founder or at least their organizer, perhaps confusing the Cofradía de Jesús with the Compañía de Jesús and their "ejercicios" with his *Ejercicios Espirituales*.

The Regis Collection includes several other representations of San Ignacio. Three of the biggest, two of them by well-known Albuquerque santeros, are shown, the Cándido García panel (**RU099**) from 1975,

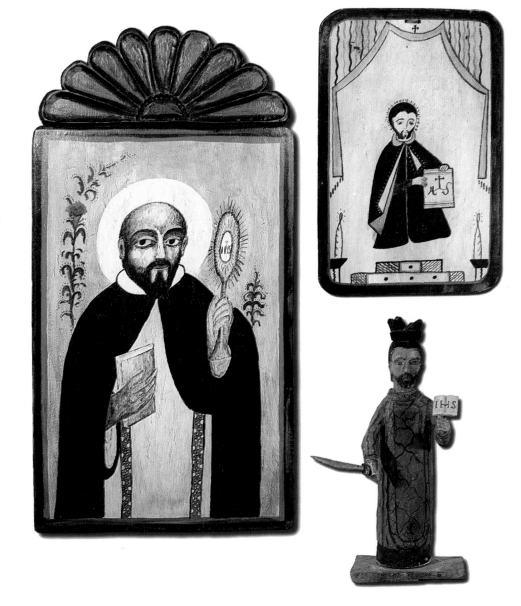

Clockwise from left:
RU 099. San Ignacio. Retablo. 59.5 x 41. Cándido García. 1975.
RU 299. San Ignacio de Loyola. Retablo. 35.8 x 23.7. Jorge Sánchez. 1965.
RU 211. San Ignacio de Loyola (?). Bulto. 31 x 11.4 x 11.5. New Mexico. c. 1830.

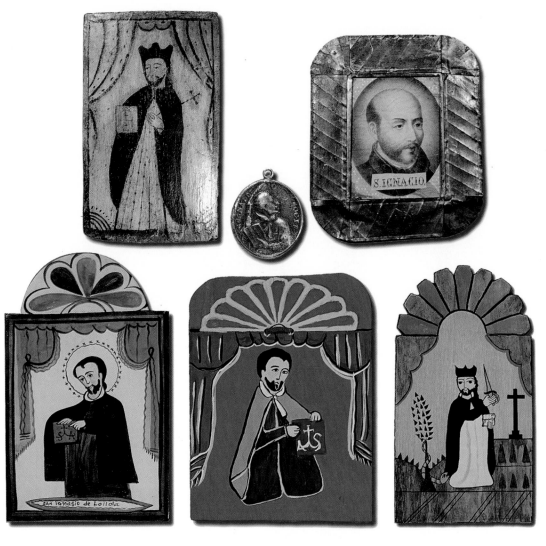

and the Jorge Sánchez panel from 1965 (**RU299**); shown with them is a very ambiguous item (**RU211**) which seems to combine a two-hundred-year-old torso, a heavy-handed job of restoration and overpainting by Frank Applegate or some other early collector or dealer, and a sword and a book that I made to complement the position of the two hands. Another six appear together, the oldest of them an eighteenth-century Italian medal (**RU137**) collected in Mexico with Ignacio on the recto and San Francisco Javier, the great Jesuit missionary to the Far East, on the verso. There is a fine small simple panel by the Arroyo Hondo Painter (**RU135**). A tin-framed print of Ignacio (**RU080**) comes next chronologically, followed by panels by Jacqueline Nelson from the late 1980s (**RU157**; a gift to us), a José Raul Esquibel panel from 1992 (**RU175**; another gift), and a Dion de Romero Hattrup from 1995 (**RU216**; it came from the young artists' area of Spanish Market).

Top row:
RU 135. San Ignacio de Loyola. Retablo. 26.5 x 16.5. Arroyo Hondo Santero. 1820-70.
RU 137. San Ignacio Loyola/San FrancEsco Xavier. Metal item. 4.9 x 4. Italy. c. 1750.
RU 080. San Ignacio. Print/tin frame. 20.5 x 17.8. Santa Fe Federal. 1840-70.
Bottom row:
RU 157. San Ignacio de Loyola. Retablo. 21.7 x 13.9. Jacqueline Nelson. 1992.
RU 175. San Ignacio de Loyola. Retablo. 23.1 x 17.9. José Raul Esquibel. 1992.
RU 216. San Ignacio de Loyola. Retablo. 24.4 x 13.5. Dion Hattrup de Romero. 1994.

THE POPE & PREZ RAID THE REGIS COLLECTION

Of course we knew months beforehand that Pope John Paul II was coming to Denver, but only a very few weeks before the event the news suddenly broke that on 12 August 1993 the Holy Father would meet President Bill Clinton on our campus. I didn't plan to be there because I'd accepted an invitation to lecture at the Albuquerque Museum, and though I knew that the woman who'd asked me would understand, I also knew she'd kill me. But pretty quickly I got a phone call from our head of Public Relations, Paul Brocker, asking if I could order up a couple of santos of Saint Ignatius Loyola, founder of the Jesuits, as special gifts to the two dignitaries. The President, after all, was a graduate of the Jesuits' Georgetown University, and if he didn't know who Saint Ignatius Loyola was I'd be ashamed of him and Georgetown both.

So I got on the phone to my good friend Charlie Carrillo, certainly among the best of the contemporary santeros, to see if he would be able to make us a couple of quick masterpieces, but as Lady Luck or Divine Predestination would have it he was out of town for several days. Not enough time! But providentially or fortuitously, we had a couple of fine Ignatius santos in our collection, then recently put on display in the Dayton Memorial Library: a bulto (statue)

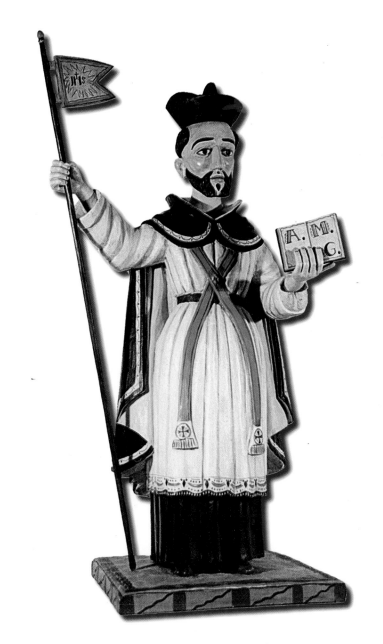

RU 202. San Ignacio de Loyola. Bulto. 76.5 x 40.3 x 31.5. Alcario Otero. 1994.

by a protege of Charlie's, Alcario Otero, and a small retablo (panel painting) by Charlie himself. Charlie himself had encouraged me to commission something from Carrie "before his prices went up," and sure enough, he had subsequently won the Bienvenidos Award (Best New Artist or "Rookie of the Year") in 1992 and Best Bulto, an even more prestigious prize, in 1993. And Charlie, a perennial award-winner, had carried off the major Best Retablo ribbon in 1992. So anyhow, there we were, with splendid Ignatius santos by two of the best santeros then working.

So by phone and fax we worked out the details: just exactly which items, how to phrase the gift-description to accompany each santo, and a few hints about what to say when handing them over. The brief ceremony of presentation shows up very well in the photograph on page 14 and on the videotape that Regis produced to memorialize the dignitaries' visit to our campus, "August 12, 1993: A Moment in History." There it happens again, just before the Pope and President board their helicopters and vanish, as Jesuit Father Mike Sheeran, President of Regis University, gives the two holy gifts to two men each of whom is, in his own sphere of influence, the most powerful man in the world.

Alcario was so pleased by our giving his bulto to the Holy Father that he offered to make its replacement (**RU202**) for the price of the original — a most generous offer, considering how his prices had escalated (just as Charlie had predicted) since he made the original. And he also told me much later

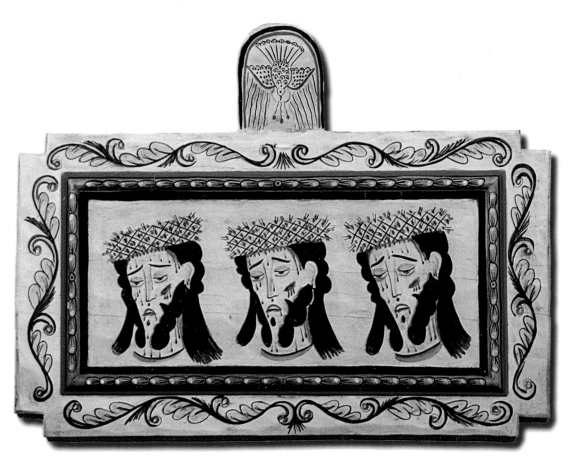

RU 293. Triple Rostro/Three Faces of Jesus. Retablo. 25.2 x 45.8. Alcario Otero. 1993.

28

how he and his mother watched the copy of the videotape and, as the presentation played itself out on the tube, fell into one another's arms weeping for sheer joy.

Getting another piece of Carrie's work pleased me very especially because it depicted the Triple Rostro — Three Faces of Christ on Veronica's Veil (**RU293**). Veronica and her veil are not at all scriptural, merely Christian folklore, so the episode is more open to creative embroidery than most, and the Taos Valley has a special local spin on it: Veronica presses her veil three times to the bloody face of the suffering Lord and receives three imprints of his face on her veil.[4]

Charlie Carrillo crafted a splendid gesso-relief panel of San Ignacio Loyola (**RU283**) to fill the gap left by the panel that the University gave to President Clinton. In addition, the Regis Collection contains several more works by Charlie Carrillo that will appear in their proper places. It also contains a few pieces by Charlie and Debbie's children, Estrellita and Roán, who

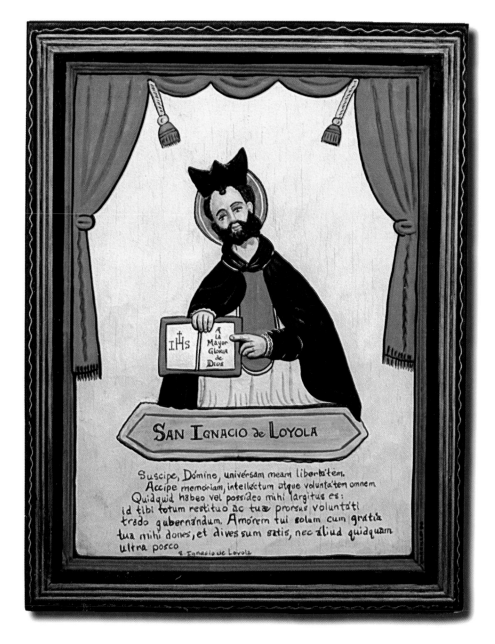

RU 283. San Ignacio de Loyola. Gesso relief. 59.7 x 45.7. Charlie Carrillo. 1996.

[4] See Thomas J. Steele, S.J., "The Triple Rostro of Arroyo Seco," *Denver Post* "Empire" (8 April 1979), 23-25, explaining the Fresquis retablo in the Denver Art Museum. A few Spanish Passiontide hymns narrate the event in the Taos manner.

have been painting and carving santos and cutting and pasting *ramilletes* (paper flowers) since their earliest years. Estrella painted a panel of San José Patriarca (**RU113**) and Roán another of San Francisco de Asís (**RU146**); each was six years old at the time. Roán said that his sister helped him some with San Francisco's face.

From left:
RU 113. San José Patriarca. Retablo. 22.8 x 14.2. Estrellita de Atocha Carrillo. 1987. RU 146. San Francisco de Asís. Retablo. 30 x 15.8. Roán Miguel Carrillo. 1991.

New Subjects & New Santeros

Once my Aunt Clare mailed me a check "to get a santo." When I wrote to thank her, I said that I would try to acquire something that would help round out the collection. Then I added, "If the collection is ever perfectly round, I'll tell you to stop sending money." A collector is like the farmer who said that he didn't want all the land in the world, he only wanted whatever adjoined his. Collecting is a form of obsessive-compulsive behavior, at least for most serious collectors. By "serious" I do not mean rich; having money might mitigate the obsessive part of the affliction, but the compulsion might develop even more seriously.

If collectors of santos have any defense, it would depend on the limited number of santeros (Get one example of each important artist) and the limited number of subjects (Get one example of each saint). When I commission a santo and don't ask for the santero's "signature" piece, I often ask the artist to depict some holy person presently lacking in the Regis University Collection.

Since there are only some hundred and seventy New Mexican santero subjects, the second of the two collector's goals is really attainable. And there was a time when I honestly thought that I could realistically expect to acquire a piece by each of the

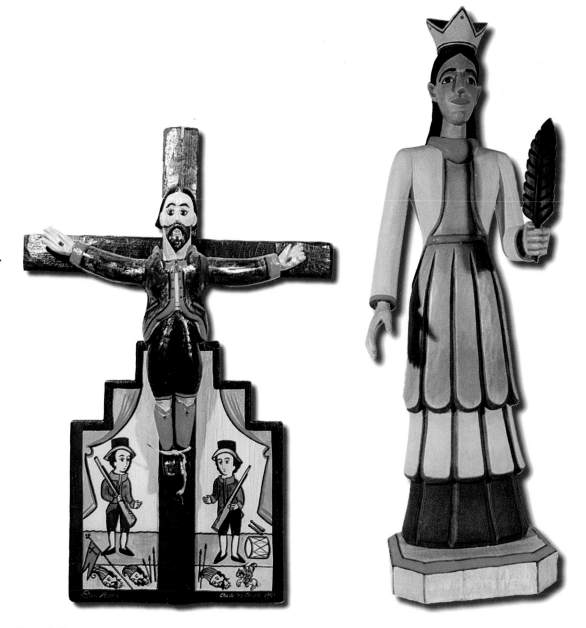

From left:
RU 111. San Acacio. Bulto. 43 x 28.7 x 8. Charlie Carrillo. 1987.
RU 147. Santa Bárbara. Bulto. 60.8 x 18.7 x 16.1. Horacio Váldez. 1991.

31

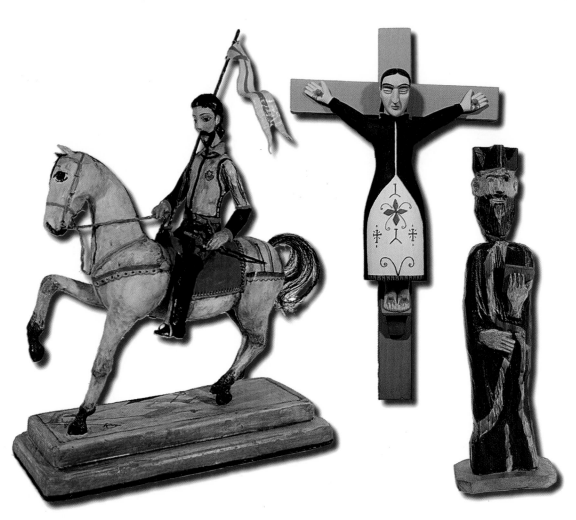

From left:
RU 142. *Santiago. Bulto. 37.5 x 27.5 x 10.5. Malcolm Withers. 1990.*
RU 164. *Santa Librada. Bulto. 49.8 x 29 x 7. Frank Brito. 1992.*
RU 166. *San Felipe Neri. Bulto. 43.8 x 9.8 x 7.8. Max Roybal. 1992.*

santeros then working; the final appendix of the original edition of *Santos and Saints* (1974) lists only the two dozen or so living santeras and santeros whom I knew of. But in the twenty-three years since the publication of that book of mine — and perhaps in some small part *because of* that book of mine — the number of santeros and santeras has increased beyond bounds.[5]

Getting exemplary santos that demonstrate how this leading santero carved and painted or how that important saint was depicted can be a reasonable and reachable goal: achieving that goal or at least approximating it makes for a good teaching collection. So a new subject and a new santero is a purchase that realizes the old saying about killing two birds with one stone.

I would like at least to mention a few such gifts to the Regis University Collection, gifts that added both a new santero and a new subject. In the late 1960s and early 1970s, santero Jorge Sánchez lived in an apartment house across from the Immaculate Conception Rectory on Seventh Street, and we came to know each other fairly well. When I began writing the first drafts of *Santos and Saints*, I thought it would be an act of sincerity to try my hand at a few

5 See *Santos and Saints*, pp. 103-14.

santos, among them a San Jorge that turned out to be a fair likeness of Jorge (despite the fact that I rarely catch a likeness). He thought it was pretty funny, and gave us our first San José Patriarca (RU028) as a return gift.

Tom and Margil Lyons donated both a cross with the implements of the passion (RU123; see page 44) and a handwritten *cuaderno* or hymnbook (RU124). The Taos santero Leo Salazar donated a tiny bird (RU165) which goes very well with our José Mondragón squirrel (RU024) and our George López owl (RU254). And finally, we have received several gifts from Mollie and Phil Freeman including a Rosina López de Short retablo of San Gabriel Arcángel (RU120; see page 72) and a pair of pieces by Earl Noell of Tesuque, a panel of an unidentified martyr-pope (RU259) and a lovely cross (RU260).

Some significant Regis University commissions in later years were a Charlie Carrillo San Acacio (**RU111**), an Horacio Valdez Santa Bárbara (**RU147**), a Malcolm Withers Santiago (**RU142**), a Frank Brito Santa Librada (**RU164**), and a Max Roybal San Felipe Neri (**RU166**), that last subject chosen because Max was an Albuquerque santero who had done an altar screen for the east transept of the San Felipe Neri Church in Old Town.

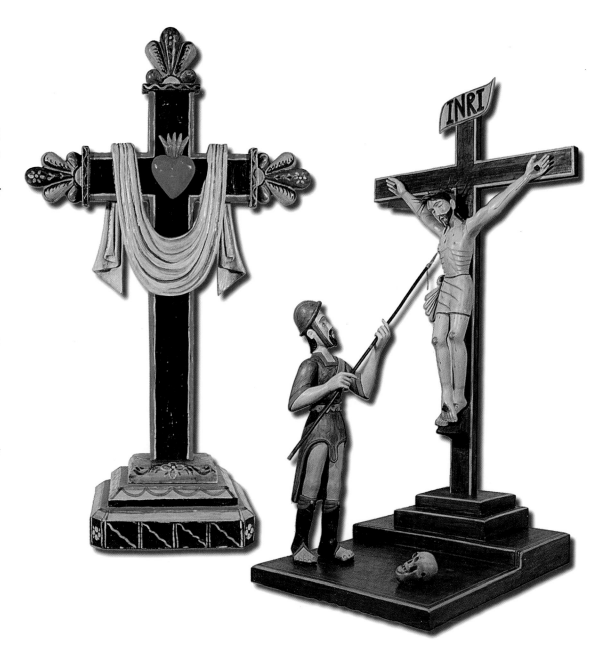

From left:
RU 277. Cruz con Sagrado Corazón. Bulto. 55 x 31.8 x 14.5. Gustavo Victor Goler. 1996.
RU 282. San Longino y Crucifijo. Bulto. 114.3 x 58.4 x 56. Félix López. 1996.

33

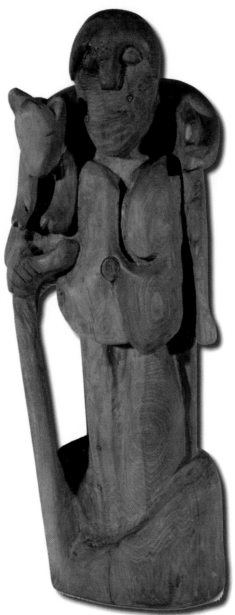

Two very recent commissions have been a splendid Sacred Heart on a Cross by Victor Goler of Talpa (**RU277**) and a large Crucifix with San Longino, the centurion who pierced Christ's side with his lance, carved for us by Félix López of Española (**RU282**).

Two ready-made acquisitions that added both santero and subject were our Pedro Fresquis retablo of San Gerónimo (**RU014**) and Patrocinio Barela's Good Shepherd bulto of unpainted wood (**RU168**). I purchased the former when it was in a perfectly filthy condition from a small shop in Old Town Albuquerque, and it cleaned up beautifully; it came endowed with the story that it was found under the floor of an old house in the neighborhood that was being razed.

From left:
RU 014. San Gerónimo. Retablo. 34 x 14. Pedro Fresquis or a follower. 1785-1830.
RU 168. El Buen Pastor. Bulto. 46.5 x 18 x 13.5. Patrocinio Barela. 1931-34.

Another two ready-made santos each of which added both a new artist and a new subject were our Quill Pen Santero retablo of Nuestra Señora del Pueblito de Querétaro (**RU210**) and an anonymous Brother's statue of Saint John the Evangelist (**RU281**) from the Penitente chapter-house at Llano de Abeyta, just northwest of the old mountain village of Truchas. Whenever the penitential Brotherhood staged scenes of the Passion of the Nazarene using statues to take the principal parts, those of Jesus, Mary, and the Beloved Disciple, this little bulto would have filled the role of John.

From left:
RU 210. Nuestra Señora del Pueblito de Querétaro. Retablo. 36.4 x 21.7. Quill Pen Santero. 1830-50.
RU 281. San Juan Evangelista. Bulto. 45.4 x 20.2 x 7. New Mexico. c. 1910.

ADDING SUBJECTS & BUILDING PATTERNS

I envy the good eye for santeros' styles that many other aficionados have. For want of it, I have instead concentrated on trying to figure out the subject of the bulto or retablo, what might be called "passive iconography." "Active iconography," by contrast, would be the santero's knowledge of how to depict a particular holy personage in such a way as to transfer his or her personal integrity to the artifact, so that the santo would make the saint authentically present to the place and time of need. Appendices in *Santos and Saints* present in a user-friendly form all the information I have gathered over thirty years of collecting; many santeros and collectors have told me they find these lists helpful.

Since there are only about a hundred and seventy subjects in New Mexican santero art, any collector interested in iconography can assemble santos that exemplify the more important and interesting subjects. Then as the collection grows, it will inevitably accumulate a telling number of the principal variants. Apart from one digression, this chapter will explore these collector's urges.

ANTONIO DE PADUA

San Antonio de Padua is one of the most popular subjects in New Mexican art, largely because of his status as the patron and protector who deals with so many of the hopes and fears that compose the Hispanic motivational profile.[5] The first San Antonio that Regis University bought was a hand-colored lithograph, very likely printed in Europe with a main title in Spanish and subtitles in French and English, enclosed in a tin and glass frame in the style of the Taos Serrate tinsmith (**RU048**). Then about ten years later we acquired a small bulto of Antonio (**RU085**) in the style that E. Boyd attributed to fray Andrés García (1720-79) but which might belong to a much less clearly defined Rio Abajo School of artists from the late eighteenth century.

The third San Antonio de Padua (**RU140**), was an interesting composite bulto with Antonio's body by Rafael Aragon (active c. 1820-62), his head by José Benito Ortega (active c. 1875-1907), and the Christ Child figure which the saint holds by José de

Gracia Gonzales (active c. 1855-1902). We cannot know for certain who of the two later santeros assembled the earlier pieces and added his own, but the motive is clear: he recycled the fragments because they are endowed with holy power.[6]

[6] By contrast, in the Orthodox traditions, the material residue of an icon that lost its formal appearance was considered to retain no intrinsic sacredness whatsoever. As the eleventh-century theological compiler Euthymios Zigabenos put it,

> We do not venerate the icons as gods, neither do we place our hopes for salvation in them, nor do we offer them divine reverence. The [pagan] Greeks did this. We only manifest though such obeisance our soul's affection and the Christian love we have for the prototypes. So if the likeness wears off, we burn the icon like scrap lumber.
>
> When we fashion an image of the cross from two pieces of wood, some unbeliever might criticize us for adoring wood, but when we separate the pieces and unmake the cross, we can then identify them as scrap lumber. And so we silence the unbelievers when we venerate the sign of the cross rather than the wood.

Panoplia Dogmatica, Chapter 22, "Against Iconoclasts," sections 23-24.

[5] See *Santos and Saints*, pp. 73-96 of the 1974 and 1982 editions, pp. 103-16 of the 1994 edition.

From left:
RU 048. San Antonio de Padua. Print/tin frame. 39 x 44. Taos Serrate Tinsmith. 1870-1905.
RU 085. San Antonio de Padua. Bulto. 19 x 6 x 4.3. Fray Andrés García. 1748-78.

Another composite bulto, generously loaned to Regis by a longtime Denver friend, is a very large Jesús Nazareno *bulto a vestir* — a statue designed to be clothed — which seems to combine a head by José Aragon and hands by José Benito Ortega (RU-R&BS183). Ortega appears for the third time in a composite, and for the second time, Ortega has reworked a José Aragon bulto, this one representing Our Lady of the Rosary; the little 1880s-style hightop "pegged" shoes and the base are Ortega's contribution (**RU-JM199**).

From left:
RU 140. San Antonio de Padua. Bulto. 38 x 10.5 x 11.8. Rafael Aragon/Santo Niño Santero (body), José Benito Ortega (head), José de Gracia Gonzales (infant) 1820-1907.
RU-JM 199. Nuestra Señora del Rosario. Bulto. 53.4 x 15.4 x 15.8. José Aragon/José Benito Ortega. 1820-1907.

RAMÓN NONATO

Our first San Ramón Nonato (**RU005**) was a panel that Eleanor Bedell "tossed in" with a nice José Aragon (RU004; see page 67) that I purchased in her Canyon Road shop during the summer of 1969. The top half of the half-cleaned retablo showed a barely-discernible original Ramón, and the bottom half sported what was left of a quite competent Guadalupe overpainted in oils. I set to work and completed the cleaning, thereby gaining an education in cleaning New Mexican santos and destroying what would have been a textbook example of an original overpainted by another hand with a different subject. It would have been a nice "parallel with a difference" to the three composites just described.

Our next Ramón was a retablo that don Gilberto Espinosa painted on a piece of light canvas that he pasted to heavy paper (**RU043**); don Gilberto had given it to Father Pierre Landry, S.J., who in turn gave it to me. The next Ramón was a quite rare retablo painted in thick oil paint on thick wood by the Eighteenth-Century Novice, again a loan from a good friend (**RU-R&BS187**), which extended a pattern and added a major early artist.

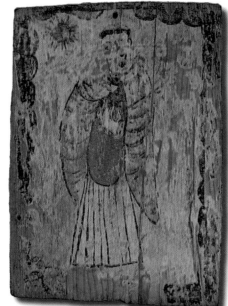

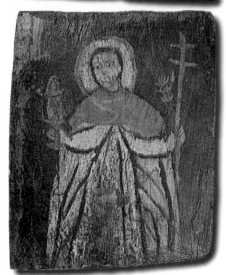

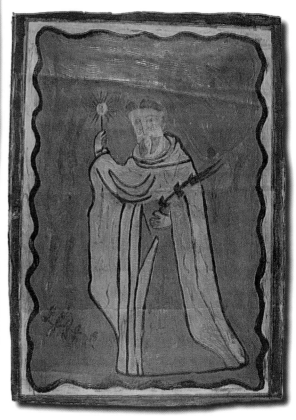

Clockwise from top left:
RU 005. San Ramón Nonato. Retablo. 29 x 21. Quill Pen Follower, 1871-80.
RU 043. San Ramón Nonato. Painting. 43 x 32. Gilberto Espinosa. 1966.
RU-R&BS 187. San Ramón Nonato. Retablo. 21.6 x 17.1. 18th Century Novice. 1780-1800.

39

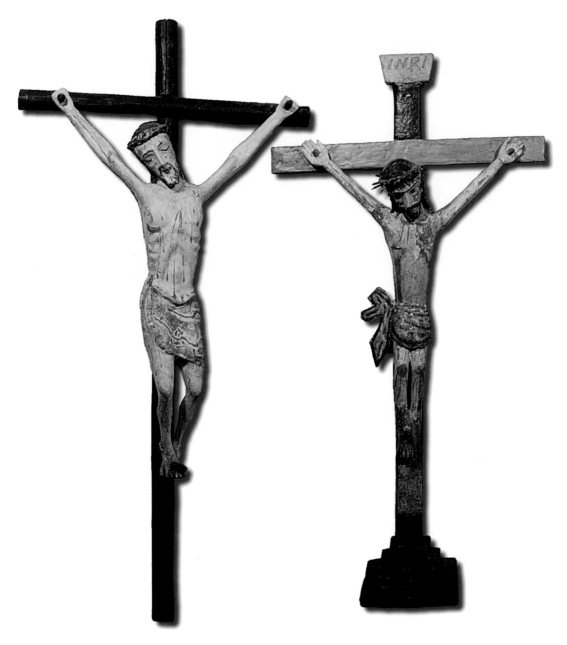

From left:
RU 018. Crucifijo. Bulto. 63 x 32 x 9. Pedro Fresquis. 1785-1830.
RU-IC 045. Crucifijo. Bulto. 67 x 36 x 15. Santero of the Delicate Crucifixes. 1810-30.

CRUCIFIXES

The first of our crucifixes, a small Pedro Fresquis masterpiece (**RU018**), required a lot of rebuilding and educated me in the ways of complex bultos. I replaced some gesso, removed the right hand (an outsize replacement hand from another bulto altogether), and fashioned a minimalist replacement for it.

The next crucifix (**RU-IC045**) is the property of Immaculate Conception Church in Albuquerque. When it came from the estate of a parishioner, it had been painted with housepaint, covered with a thick and shapeless coating of plaster, and housepainted again, so it was truly an uninviting sight. There were only a very few spots where the original homemade watercolors showed through, but what I could see encouraged me to give it a try; so with the permission of the Jesuit pastor Joseph Malloy, I began to attack the overcoatings, which fortunately yielded readily to acetone, paint remover, and gentle manual persuasion. The original gesso was missing in a few spots and needed replacement, but the crucifix emerged as a worthy companion of the Fresquis. Larry Frank eventually identified it as part of a style group he named "The Delicate Crucifixes."[7]

7 Larry Frank, *New Kingdom of the Saints* (Santa Fe: Red Crane Books, 1992), pp. 145-53.

I have juxtaposed a José Benito Ortega angelito with chalice (**RU203**) with the next crucifix, which is also by Ortega (or perhaps by an Ortega follower; **RU097**). As the numbers suggest, the two santos were acquired at widely different times, and the merest educated glance reveals that the angelito is somewhat too large for the crucifix. But as the Spanish poetic formula "Jesús sacramentado" indicates, by dying on the cross Jesus completes the process of becoming the principal sacrament of the human encounter with the divine, the Eucharist; and placing the angelito's chalice next to the spear-wound in Christ's side (John 19:34) clearly connects the sacrifice of Calvary and the sacrament of Christ's body and blood. Christ's loincloth really looks more Plains-Indian than New Mexican, more like a parfleche than a loincloth.

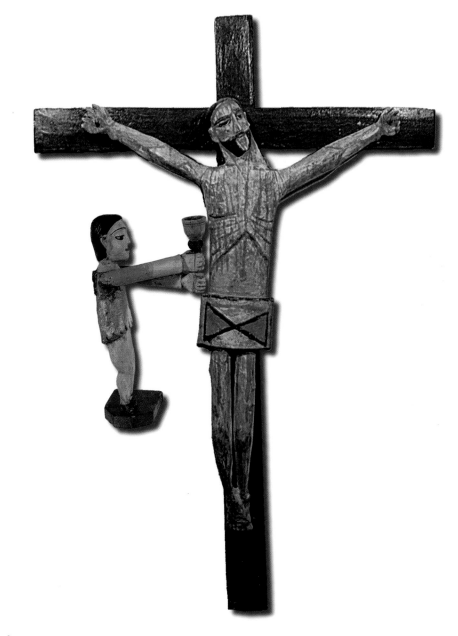

From left:
RU 203. Angelito con cáliz. Bulto. 23.5 x 7.7 x 13.4. José Benito Ortega. 1880-1907.
RU 097. Crucifijo. Bulto. 23 x 56 x 7.3. José Benito Ortega. 1880-1907.

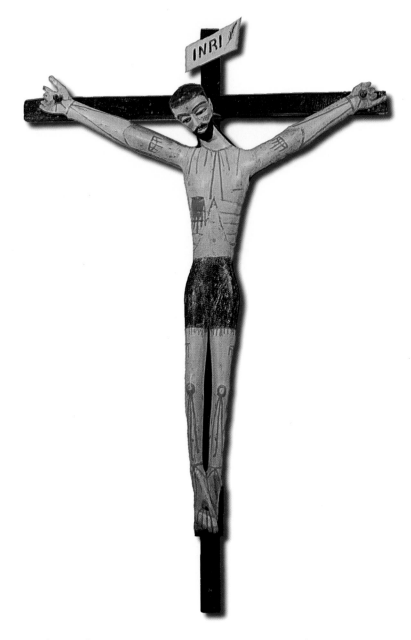

Another loan from that Denver friend, the next crucifix (**RU-R&BS184**) is an extremely imposing masterpiece by Juan Ramón Velásquez. The INRI is painted in oil paint on a piece of tin.

RU-R&BS 184. Crucifijo. Bulto. 119.4 x 78 x 19.5. Juan Ramón Velásquez. 1870-1900.

CROSSES

Three crosses in our collection make a special group. One of them, **RU093**, comes from the Pueblo of Santa Ana where Elmer Leon practices the old Hispanic tradition of straw applique. The middle cross, **RU092**, lies at the farthest fringe of Hispanic santo tradition since it derives from Jémez Pueblo. It was blessed during the Christmas season or on Palm Sunday so that it might bless the crops, but the family noticed my interest in it and gave it to me when I was visiting them during one of their fiestas. And finally, **RU118** is a piece by Jimmy Trujillo of Abiquiú and Albuquerque; the red is a traditional though rare color.

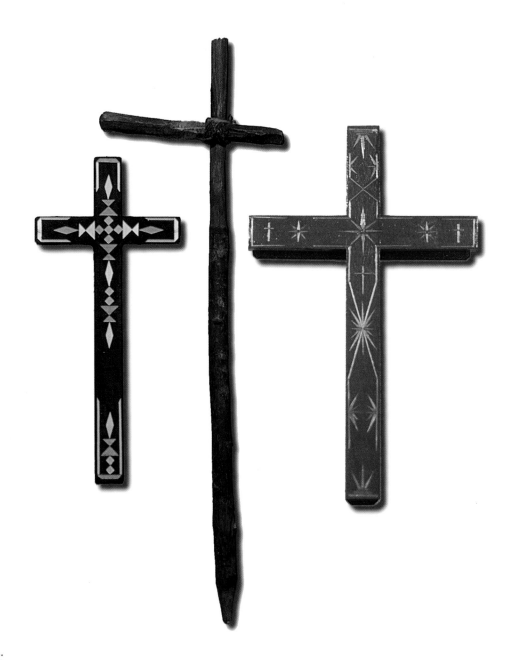

From left:
RU 093. Cruz. Straw-Inlay. 14 x 6.4 x 0.8. Elmer Leon. 1984.
RU 092. Cruz. Wood item. 30.8 x 10.5. Jémez Pueblo. 1984.
RU 118. Cruz. Straw-Inlay. 19.6 x 12.7 x 0.7. Jimmy E. Trujillo. 1987.

43

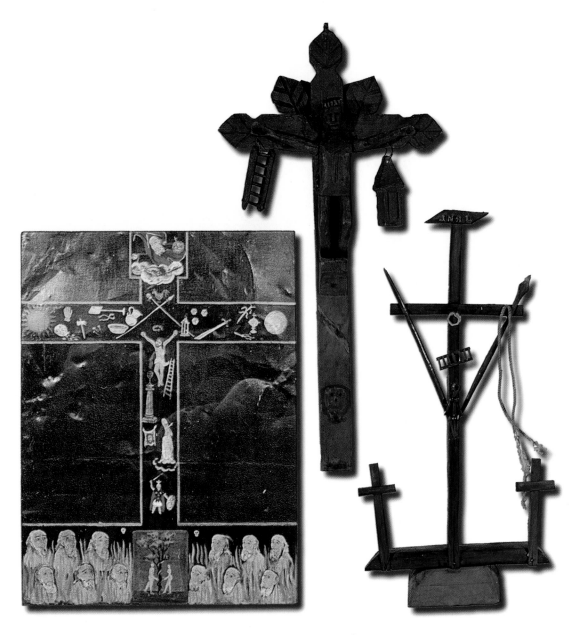

CROSSES WITH THE ARMA CHRISTI

An interesting variation from ordinary crosses are those that display the Arma Christi — the Weapons of Christ, not those Christ used against enemies but those he allowed to be used against himself. The list seems nearly endless, and some displays run to several dozen implements of the passion; the most common are the "I.N.R.I.," crown of thorns, nails, rope, ladder, skull of Adam, lance, and sponge on a pole.

A splendid oil-on-copper painting from nineteenth-century Mexico (**RU225**), a gift of Mr. and Mrs. Thomas Rollins, has the fullest set of Arma, so many that they can serve first as a sort of visual riddle and then as a meditation device to draw the devotee closer to Jesus in his suffering and death. José Dolores López of Córdova made **RU258**, which has lost Christ's halo and various implements such as the "I.N.R.I.," lance, and sponge on a pole, but it still possesses the ladder, the lantern, and Adam's skull. And item **RU123**, the Lyons' gift to us from Chama, Colorado, sports the "I.N.R.I." (with alphabet-soup letters), spear, crown of thorns, rope, sponge on a pole, pincers, hammer, nails, and the smaller crosses of the two thieves.

From left:
RU 225. Arma Christi cum Animis. Oil on copper. 41.9 x 33. Mexico. c. 1830.
RU 258. Crucifix (Arma Christi). Wood item. 36.4 x 19 x 3.7. José Dolores López. 1930-38.
RU 123. Cruz con los Arma Christi. Wood item. 41 x 19 x 10.5. Colorado. c. 1920.

SOME ESPECIALLY NICE GIFTS

I recall dropping into Wright's Trading Post, one of the truly ancient Albuquerque commercial institutions, when it was still downtown on the south side of Central between Third and Fourth, where Garson's is now. When Mr. Wright and I got to talking about his splendid private collection of Native American artifacts, he complained to me that the Albuquerque Museum — then about to open in its new building in Old Town — did not seem the least bit interested in purchasing his collection. Prefacing my remarks with a polite apology, I speculated that the museum was justly confident that if it had attractive display facilities and adequate storage space, good people would donate good things and do a great deal of the work of building the Museum's collections.

How it has in fact worked out for the Albuquerque Museum I know not, but my theory has worked pretty well for the Regis University Santo Collection. Over the years, people of many sorts have come forward to offer to give us things they appreciate and value. These quite diverse persons seem to have only two traits in common: they are very generous and very nice.

A few examples will suffice.

Since 1968, the Jesuits have owned a summer place in the Nacimiento Mountains just east of Cuba, New Mexico. Just as we bought it, I moved up to Regis, and there I learned of a 1968 graduate who had taken a teaching job in the Cuba schools. So the next summer when I spent time in the cabin, I phoned Brad Earlywine and we agreed to meet.

Brad had become friends with the family of the last Hermano Mayor (Elder Brother) of the local *morada* (chapter house) of the penitential Brotherhood of Our Father Jesus the Nazarene, and when we got together he took me over to the *morada*, which had become inactive because the last few surviving Brothers became too old. During the years after World War II, recruiting fell off because nearly all the younger men set suburbia as their goal.

In 1969, a few hours of sweeping and dusting would have served to restore the oratory and the *morada* proper to a useable state, and a good day of hard work would have replaced the roof of the *dispensa*, the small storage room attached to the *morada*. But that was not to be.

For several years, I watched the two buildings fall down. When it looked as if the remaining roofs might fall in, I decided to talk to Mrs. Rosalía Casaus, the Hermano Mayor's daughter and the owner of the property on which the buildings sat. I drove to her home, identified myself as a Jesuit priest, a santo freak, and a friend of Brad Earlywine's, and asked her if it would be all right for me to go up to the *morada* and retrieve from it anything that I thought was worth saving. I promised to return to the house and show her whatever I had in the car.

Upon her assent I went to the morada buildings and collected all the pieces of white-painted wood I could find. When I returned to the house, Mrs. Casaus came out to the car, looked in the back seat, and said "Keep it." I thanked her, though at the moment I had no idea what I was thanking her for. I took what I had up to the Jesuit cabin, laid everything out on our large porch, and began matching nail holes; in a few hours I had assembled the display altar (RU047) nearly as it is now — lacking a few missing pieces that had gone to toasting marshmallows and so forth. It really was fine present to us, for it has shown off many of our bultos to great advantage for nearly twenty years. For this is a display altar — not an altar for a priest to say Mass but instead an altar designed to sit on a table so a chapter of the Brotherhood can display its santos in real style.

A "carpenter neo-classical" style characterizes the item, very much in the manner of Territorial architecture and the

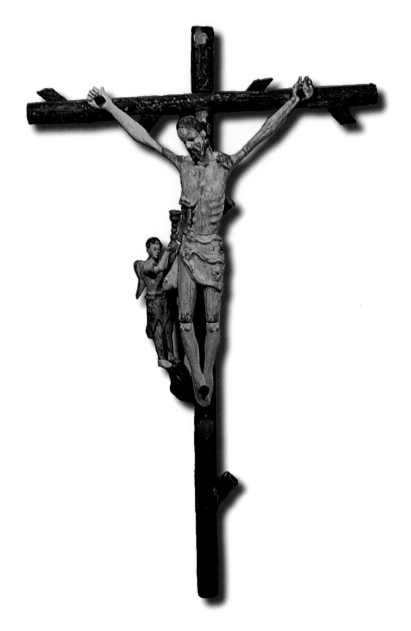

RU 066. Crucifijo de Esquipulas con angel. Bulto. 75 x 47. Antonio Molleno. 1800-40.

tin-and-glass items produced by the Santa Fe Federal Workshop in the middle of the nineteenth century. But there may also be an echo of the Pueblo cloud-stairstep design in the rail that sits between each pair of neo-classical columns.

I stopped back to see Mrs. Casaus after she moved to Albuquerque a year or so later, gave her copies of a couple of my books, and thanked her for her generous gift. She seemed very pleased that something from her father's beloved morada had been rescued from the brink of decay.

The devotion to the crucified Lord of Esquipulas originated in Guatemala and spread northward into many parts of New Spain, including both Durango, the see city of the bishops who claimed jurisdiction over New Mexico, and several cities and market towns along the Camino Real. In 1979 Mr. and Mrs. Carmen J. Vigil gave Regis the parts of a tree-of-life Esquipulas crucifix with a little angel catching the blood in a chalice that had come down in the Vigil family (**RU066**). It was a wonderful piece, but it was missing numerous rather major parts — Christ's and the angel's heads, one of Christ's arms and his legs from the knees down, and the angel's arms from elbows to hands inclusive — and numerous minor parts. I was delighted to find that a small head that

don Gilberto Espinosa had given me fit perfectly on the angel's neck. I made the rest of the parts, but by the time I realized that the piece was a Molleno, I had already carved, painted, and grafted a Fresquis-style head onto the Cristo.

Then fifteen years later, Dorothy Shaw donated the San Miguel bulto to be discussed shortly, and it turned out that the head attached to the figure was nothing other than a head from a Molleno crucifix. It would have been perfect if the head had been a trifle bigger, but it was certainly a stylistic improvement over the Fresquis-Steele novice noggin.

The southern New Mexican almud grain-measure (**RU083**) that the Freemans gave us is hardly a santo, but it reminds the viewer of an important dimension in the life of a people who raised on their own land with their own hands the vast majority of what they ate. In that world, a shortage of food in the house was not merely an occasion for a quick trip to the supermarket; devout New Mexicans instead tended to interpret it as their own failure to be sufficiently religious, their not having prayed with enought fervor and perseverance.

My friends Fred Birner and Jim Gerken donated the marble heart (**RU141**) from San Miguel County. It was crafted from a fragment of a slab of commercially cut marble, probably by a Brother of the penitential Brotherhood of Our Father Jesus the Nazarene — and quite possibly worn on a thong around his neck as a penitential reminder of Jesus' love.

RU 083. Almud. Wood item. 25 x 31 x 13.5. Socorro del Sur, TX. c. 1890.
RU 141. Sagrado Corazón. Stone item. 7.4 x 6.8 x 2.2. New Mexico. c. 1895.

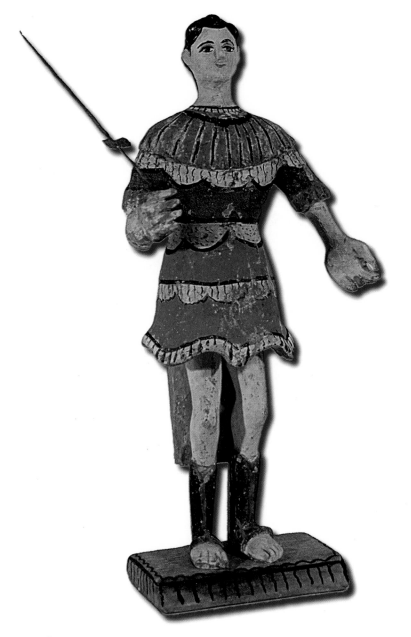

Barbe Awalt, Paul Rhetts, Charlie Carrillo, and I were to sign our books at Shirley Jacobson's Books Unlimited in Santa Fe, and to attract a good crowd Charlie and I offered to identify santos — one to a person. One extremely nice person, Dorothy Shaw, brought two santos, but we let her because she generously donated them to us — one to Charlie for the Abiquiú morada and the other to me for Regis. Our San Miguel (**RU236**) was mentioned above in connection with the Molleno crucifix; it needed a great deal of work, including a thorough cleaning and a new head to replace the too-small Molleno head of Christ crucified, but with a lot of apprentice work on my part and a lot of skilled help from Charlie, Regis came away with a wonderful santo, a prime example of the work of the Rio Abajo style-group still in the process of being defined.

The red outfit is much more typical of San Rafael, so the late-nineteenth-century sword may have transformed this bulto into a San Miguel.

RU 236. San Miguel Arcángel. Bulto. 38 x 7.3 x 12.7. Provincial Academic II. c. 1800.

ADDING SANTEROS

Despite my personal tilt toward the santo subjects and the iconography that goes with them, I'm totally convinced that the santeros past and present are the vital and creative fountainhead of the tradition. Therefore I have always set as a high priority the acquisition of santos by the key painters and carvers of the original folk tradition and the twentieth-century revival tradition that continues today.

From time to time I have had an opportunity to add a piece by a major early santero to the Regis Collection. The Laguna Santero's bulto of San José Patriarca (**RU139**) is one such prize. Since this master worked from the very last years of the eighteenth century into the first decade of the nineteenth and since he seems to have exercised a major influence on Molleno and through him on many subsequent artists, his work is especially rare and especially treasured.[8] Some restorer reworked this elegant statue of Jesus' earthly father so that his arms and hands assume strange postures. I added the flowering staff, one of Joseph's invariable attributes, mainly because it adds three-dimensionality.

Bernardo Miera y Pacheco (1719-85), who is even earlier than the Laguna Santero, rarer not only because of his greater antiquity but because he was busy with other parts of his career, influential through the Eighteenth-Century Novice and his son Manuel, and doubly prohibitive because he normally produced much larger pieces than most other santeros.

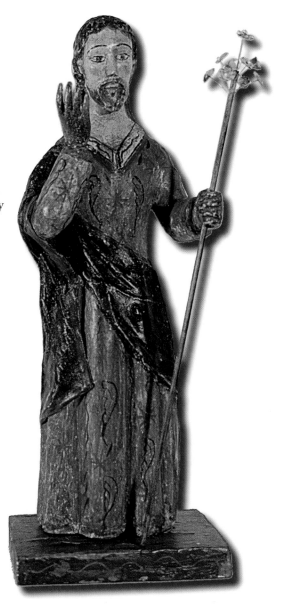

RU 139. San José Patriarca. Bulto. 45 x 15 x 13. Laguna Santero. 1790-1809

[8] Even rarer and more treasured to the point of simple unavailability at any price — or what come to the same thing for a fairly meager budget, unaffordability at actual prices — is the work of don

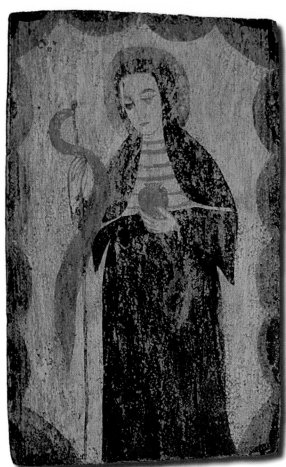

The A.J. Santero is, my friend Larry Frank tells me, an underappreciated artist. We early acquired a nice Santa Gertrudis (**RU020**), which belongs to the "brown-cartoon" part of the santero's work, and then a few years later a poorly restored "blue-cartoon" Nuestra Señora de los Dolores (**RU110**) came up for sale in a Canyon Road shop in Santa Fe. I was able to convince my Jesuit superior to buy it largely on the grounds that it was a good investment; but as the years have gone by I wonder more and more if I could ever easily part with it, for it has gotten a skillful second restoration at the hands of Marie Romero Cash, and it serves as a fine example of what might be termed "The A.J. Santero's Blue Period."

From left:
RU 020. Santa Gertrudis. Retablo. 30 x 18. AJ Santero. c. 1822.
RU 110. Nuestra Señora de los Dolores. Retablo. 26 x 18.5. A.J. Santero. c. 1822.

Several years ago it dawned on me that, whatever we think today of his ability as a santero, Frank Applegate (d. 1931), close friend and fellow-aficionado of the santos with Mary Austin (d. 1934), was a major figure in santo history because he and Austin successfully revived the making of New Mexican santos. They recruited the artists, mandated the subjects, decided on the appropriate style, and made the market, mainly among their wealthy and sophisticated Anglo friends. This small retablo (**RU181**), which Nat Owings was kind enough to save for me, carries on its reverse a period label that reads "San Cristobal. Presented by Frank Applegate to Mary Austin on her 60th birthday 1928."

RU 181. San Cristóbal. Retablo. 19.7 x 12.4. Frank Applegate. 1928.

The first of the artists that Applegate and Austin recruited, Celso Gallegos of Agua Fria, made innumerable renditions of San Jorge — a subject quite rare in the older New Mexican tradition but popular among Santa Fe Episcopalians. The Regis Collection Saint George (**RU209**) is a low relief of wood stained but left unpainted (probably because Applegate did not trust his proteges to use paints in moderation), and it came to us from the collection that Austin's first biographer, Dr. Matt Pearce of the UNM English Department, assembled in the 1930s and '40s. Another longtime Agua Fria santero, Efren Martínez, shows the same unpainted low relief of wood in his otherwise very Mexican Santo Niño de Atocha (**RU132**).

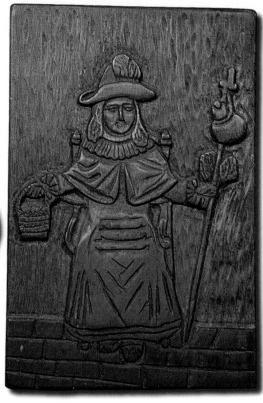

From left:
RU 209. San Jorge. Carved relief. 13 x 16.7 x 5.1. Celso Gallegos. 1910-1943.
RU 132. Santo Niño de Atocha. Carved relief. 34.5 x 23.4. Efren Martínez. 1938.

Elmore "Elmer" Shupe of Taos grew up in Canjilón, began collecting and reselling various Hispanic arts, and eventually became the leading dealer in the Taos region. I saw this Divino Rostro (**RU176**) — the face of Christ on Santa Verónica's veil — on consignment in a Central Avenue shop very near Sixth Street, ran home to the rectory to check the initials against my listing of twentieth-century santeros, and ran back to the shop with my checkbook in my hand. I later met the owner, Robert Kerr, and through him I had the pleasure of meeting two of Shupe's children, one of whom, Howard Shupe, has followed in his father's footsteps as a santero.

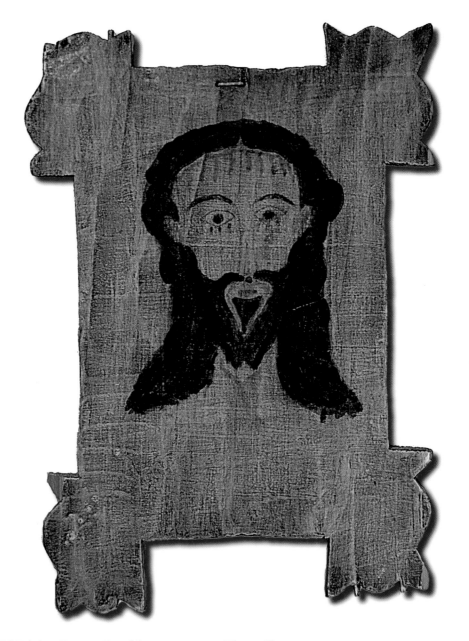

RU 176. El Divino Rostro. Retablo. 34.5 x 24.8. Elmer Shupe. c. 1955.

Other name artists I have a particular delight in collecting are Jimmy Trujillo (RU118; see page 43), Nicholas Herrera (**RU212** and RU213), Ernie Lujan (**RU250** and RU294), Frankie Nazario Lucero

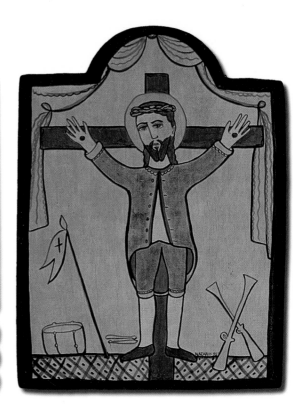

From left:
RU 212. Santa Rosalía. Retablo. 35 x 23.2. Nicholas Herrera. 1994.
RU 250. Nacimiento (crib scene). Retablo. 41.5 x 28.5. Ernie Lujan. 1995.
RU 252. San Acacio. Retablo. 30.3 x 22.8. Frankie Nazario Lucero. 1995.

(**RU252**), David Nabor Lucero (**RU214**), Floyd Trujillo (RU222), Jacobo de la Serna (**RU206** and RU290), and James Córdova (**RU251**). Many of these men have relationships among themselves (or with other santeros I've collected) as blood relatives, as master and pupil, or as fellow members of the penitential Brotherhood.

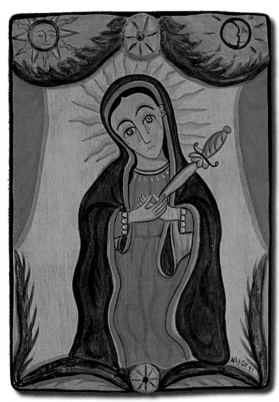

From left:
RU 214. Nuestra Señora de los Dolores. Retablo. 25.8 x 18.4. David Nabor Lucero. 1994.
RU 206. Sagrada Familia. Retablo. 41 x 61.1. Jacobo de la Serna. 1994.
RU 251. San Lorenzo. Retablo. 50 x 35. James M. Córdova. 1995.

RU 030. Penitente matraca. Wood item. 24.5 x 29.5 x 8. Max Vigil. 1934.

OTHER MATERIALS

Robert Shalkop's perceptive title *Wooden Saints* points to the hidden core of the classic-period santos about which he writes in his 1967 classic, the cottonwood root and the pine panel that the nineteenth-century santero covered with gesso and then painted with homemade watercolors. But santeros from those bygone days to our own have used many other materials in depicting the santos, and a teaching collection ought to acquire pieces that exemplify the extent of what the santeros thought admissible materials.

WOOD

The *matraca* is a ratchet noisemaker used in church services only during the last two weeks of Lent, when bells were not permitted. But the penitential Brotherhood used *matracas* not only throughout the year to suggest the spirit of Lent but especially in the *Tinieblas*, their Good Friday enactment of the chaos that attended Christ's death. Max Vigil of La Garita, CO, made and inscribed this *matraca* (**RU030**): "A Credo in honor of the Great Power of God for the life and health of Brother Max Vigil, 29 March in the year of the Lord 1934."

I was tour-guiding some novices from the Denver novitiate out to Ácoma one early-summer day in 1988 when we missed the turnoff from I-40 and had to go on to the Budville exit. As long as we were there, I thought it would do them good — a major consideration when dealing with novices — to take a glance at some aspects of the Hispanic culture and not spend the entire day on the Pueblos, so we went into Cubero, parked in front of the morada, and looked around. The roof of the oratory had collapsed, and the morada proper and its storage rooms would soon follow, but there were several items of morada furniture that I thought were too good to be merely crushed. Trips to the post office and a private home in the village got me started, innumerable phone calls through the remaining months of the summer kept the thread alive, and finally by late August I had gotten permission to take whatever furnishings I thought worth saving on condition that I make a donation to the pastor at San Fidel earmarked for the Cubero chapel. One of the four items Regis received was a small coffin (**RU128**) made to carry the statue that represented Christ's dead body during the enactment of the final few Stations of the Cross. It is made of light milled lumber held together with nails and painted with thin

blue and yellow paint, and on the legs are a set of commercial metal claw feet each of which holds a glass ball.

A *tiniablero — Tenebrae* candelabrum (**RU125**) is another of the Cubero pieces. It has numerous tin candleholders for the candles that are extinguished one after

another as the stanzas of Passiontide hymns are sung on Good Friday evening; and when the morada is ultimately reduced to absolute darkness, absolute pandemonium breaks out to represent the chaos that the world lapsed into at the death of Christ.

RU 125. Tiniablero/candelabrum. Wood item. 174.5 x 95 x 49.6. New Mexico. c. 1915.
RU 128. Cajon del Santo Entierro. Wood item. 67 x 149 x 47. New Mexico. c. 1920.

The Albuquerque santero Luis Aragon (1899-1977) sculpted in unpainted pine and cedar, to which he often added small pieces of rock, string, leatherette, tinted cloth, and other such materials that supplemented the different natural colors. His San Isidro (**RU033**) is a splendid high point in the Regis Collection, which has eight Luis Aragon items in addition to the one shown here.

George López' grandfather Nazario Guadalupe López is believed to have created the first New Mexican Death Cart, an allegorical image of death riding in an old-fashioned oxcart. In the spring of 1977 the old *Colorado Magazine* accepted an article of mine on the death image, so to celebrate I commissioned this piece (**RU055**) for the collection. Charles L. Briggs subsequently told me that one of George and Silvianita's grandsons, most likely Alex, had actually made it, but since it came off George's "*mesa* — table," he signed it when I asked him to.

From top:
RU 033. San Isidro Labrador. Bulto. 27 x 43 x 17. Luis Aragon. 1973.
RU 055. Carreta de la Muerte. Bulto. 63 x 103 x 38. George T. López. 1977.

Tin

The Nuestra Señora de la Purísima Concepción (**RU271**) was a gift from Agustin Quintana, an old friend on the staff of the Jesuits' Immaculate Conception Church in Albuquerque; the tin was crafted in the Valencia County Red-and-Green tradition. The tin cross with the handwoven wool fabric (**RU275**) was a gift from the creators, Rita and Juan Martínez of Española, who were in Denver for the 1995 Chili Harvest Festival at the Botanical Gardens.

From left:
RU 271. Madre Purísima-Mater Purissima. Print/tin frame. 25 x 21.1. Valencia Red & Green Workshop 1885-1910.
RU 275. Cruz. Fabric/tin frame. 42.4 x 34.6. Rita and Juan Martínez. 1995.

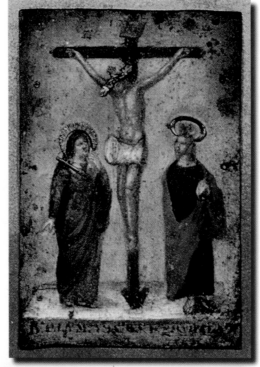

Any painting in oils, whether on tin, copper, or canvas, almost invariably comes from outside New Mexico. The Esquipulas Calvario scene (**RU244**) is a particularly interesting oil-on-tin lámina not because the painting is superior but because the three halos and Mary's sword are crafted of solid silver. By contrast, the popular ex-voto genre, for all its lack of sophistication, has profoundly influenced Mexican academic art for the past hundred years and more. Our ex-voto (**RU041**) comes from San Pedro de las Colonias, about 25 miles east of the Camino Real in the northern Mexico state of Coahuila. The legend reads,

> In the year 1896 Benito Rivera suffered a verbal attack by some individuals which threatened him with great ruin, so he commended himself to the holy little Emmanuel Child of San Pedro. He presents this [painting] so as to increase his devotion.

The Christ Child enthroned on the cloud is none other than the Niño de Atocha, evidently known regionally by the pet name "Santo Niño Manuelito de San Pedro."

From top:
RU 244. La Milagrosa Imagen del Señor de Esquipulas. Oil on tin. 38.1 x 32.4. Mexican. c. 1850.
RU 041. Santo Niño de Atocha. Oil on tin. 18.5 x 25.5. Mexico. 1896.

OTHER METAL

Regis acquired these ten *milagros*, which are tokens awarded to a holy personage for a favor received (**RU056, RU075, RU116**). A milagro can represent any one of three main components of the favor: (1) the holy personage who responded to the prayer — Our Lady of Sorrows, represented by the pierced heart; (2) the donors who had prayed for some favor and received it — the three kneeling figures; or (3) the person or thing that had fallen into jeopardy — the eyes, the arm, the leg, and the domestic animals.[9]

[9] A kneeling figure could show the donor simultaneously as potential victim and as orant — praying for his or her own rescue.

RU 056. Two milagros. Metal item. 1 x 3.1. Mexico. c. 1950.
RU 075. Four milagros. Metal item. 4 x 1. Mexico. c. 1950.
RU 116. Four milagros. Metal item. 3, max side. Mexico. c. 1950.

CLOTH

Regis has some items of cloth which typify that dimension of the santero world. The "Carson" colcha of Santa Rita (**RU017**) takes its name from the Taos County town named for Kit Carson the scout; it was largely populated by families in which the husbands were Anglo Mormons and the wives were Hispanic Catholics. Elmore (Elmer) Shupe encouraged the women to make wool embroideries that depicted Catholic saints and offered to sell the pieces in his shop just south of Fernando de Taos.

This oil painting of Christ crucified by José de Gracia Gonzales (**RU169**) was at one time stretched and framed, but the Brothers of a Pecos Valley morada in San Miguel County hung it from a horizontal bar fastened to the top of a pole so it would serve as the *guia* — guide at the front of their processions. The Smithsonian was quite interested in this piece, but we managed to get our nickel on the counter before they got their dime on it, and we came away with it.

Paño art is handkerchief art, pictures drawn originally by prisoners with ballpoint pens on bedsheets and handkerchiefs. Many are secular in subject, but many santos appear as well. This unsigned *paño* (**RU231**) may have been commissioned from the prisoner-artist by another prisoner as his gift for a relative's marriage.

At left: RU 169. Guia de Jesús Crucificado. Oil on canvas. 95 x 69.5. José de Gracia Gonzales. 1865-1900.
Upper right: RU 017. Santa Rita de Casia. Fabric. 33 x 25. Carson Group. 1931-45.
Lower right: RU 231. Paño (handkerchief). Fabric. 42.6 x 42.6. Jimmy Martínez. c. 1990.

PAPER

This crucifixion scene (**RU076**), drawn with marking pens on a piece of white corrugated cardboard, was glued to a plywood panel in a construction walkway along Central Avenue in downtown Albuquerque; I "liberated it" when the walkway was about to be removed. It is a good example of an item that belongs in a teaching collection — and perhaps nowhere else.

As European-American philosophy is said to be little more than footnotes to Plato, so the books of the last twenty-odd years may be said to be little more than footnotes to E. Boyd. So to conclude, the great E. Boyd oversaw the printing and hand-coloring of the New Mexican "Portfolio of American Design" for the W.P.A. This Santa Verónica with her veil showing the imprint of Christ's face (**RU298**) dates from about 1939.

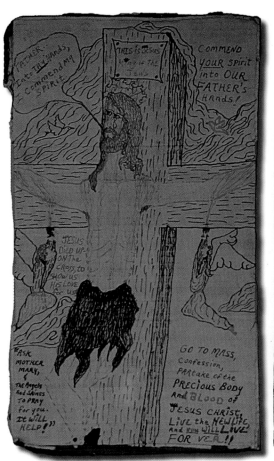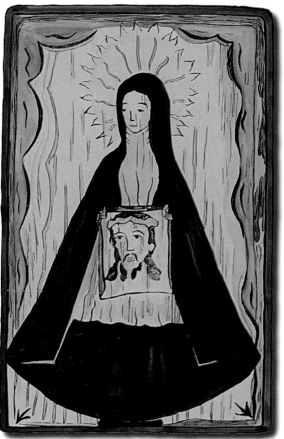

From left:
RU 076. Crucifijo. Pen drawing. 43 x 26. New Mexico. 1982.
RU 298. Santa Verónica con el Rostro. Print. 30.3 x 20.5. E. Boyd/WPA Artists. 1939-40.

RU 121. Nuestra Señora del Refugio. Retablo. 25 x 12. José Aragon /Arroyo Hondo. 1820-70.

Epilogue

Some might find it inappropriate that a priest actively collects santos. There is that problem with the Jesuit vow of poverty, and the whole idea of "hoarding" icons of the Church may cause one to think about the motivation behind Tom Steele's thirty years of collecting. But if you think about this process long and hard, the beauty of his collecting the santos is the fact that Tom is a priest. If anyone can appreciate them and share them with others it is someone like Tom.

In many ways Tom looks at the images differently than other collectors, santeros, or museum curators. The true purpose and the inner dialog that takes place between one who believes and the carved and painted images of the saints make these santos different from works of art or investment commodities. The whole question of worth really just clouds the issue for Tom. If they weren't worth a cent, he would probably still collect them because in many ways they are the documentation of faith through the last four hundred years.

The Regis University Collection of New Mexican Santos is not the only collection that Tom has assembled for Regis. He also has managed to beg and borrow a small teaching collection of Native American artifacts, and the items serve as a testament to the fact that Tom's interest in all peoples drives him to collect and share.

Santos and Saints, written by Tom Steele in 1974, has been the Bible of santo collecting and appreciation through three editions. Those of us who spend time trying to fine tune our own appreciation of the New Mexican saints would find our task far harder without the observations Tom has committed to paper over twenty-seven years.

Tom has been a very prolific writer on many subjects. His further involvement with Regis includes the recent release of *Adducere II: The Faculty Lectures at Regis College of Regis University, 1987-1993.*

In December 1996, Tom retired from teaching at Regis University to move to New Mexico. It is Regis' loss, but this is time that has been stored up for the projects that are near and dear to Tom's heart. He has so many writing assignments in the air that it is hard to image how he figures out what he is doing at any given point in time. The research on santos that he is doing with various "partners in crime" may prove to be some of the most important findings to the art world in modern times, though Tom would never put it that way.

Some people know Tom as a cowboy, others as a priest, still others as an art historian, and others yet as a writer. Practically all of them know him also as a friend. But in all of his dealings, and in his many and varied interests, Tom remains always a teacher. The Regis University Collection of New Mexican Santos is a lasting testimony to a man who recognized the beauty of the New Mexican santos before it was fashionable to do so and shared them with the rest of us. The Regis University Collection is a true gift to all of us in the present, and it will continue to serve as a gift to many more persons in the future.

Paul Rhetts and Barbe Awalt

From left:
RU 219. Jesus der Erloser [Redeemer/Ransom]. Print/tin frame. 33 x 27. Valencia Red & Green Tinsmith. 1870-1900.
RU 220. St Joseph der Vater des Waifen. Print/tin frame. 33 x 28. Valencia Red & Green Tinsmith. 1870-1900.

The Regis Santos: A Complete List

(All sizes are in centimeters — 2.53 cm. = 1 inch)　　　　　　When made

RU 001	Santa Rosalía	Retablo	28 x 21	José Aragon	1820-35
RU 002	Nuestra Señora de los Dolores	Retablo	31x 23	Antonio Molleno	1820-40
RU 003	Santa Rita de Casia [lost]	Retablo	14 x 20	José de Gracia Gonzales	1865-1900
RU 004	Unknown male saint	Retablo	19 x 15	José Aragon	1820-35
RU 005	San Ramón Nonato	Retablo	29 x 21	Quill Pen Follower	1871-80
RU 006	Jesús Nazareno	Bulto	22 x 5.7 x 4.5	Mexican provincial	c. 1890
RU 007	Head [used with RU 066]	Bulto	3.5 x 2.7 x 2.7	New Mexico	c. 1840
RU 008	Nuestra Señora de Guadalupe	Carved relief	47 x 30.1	WPA	1930-1940
RU 009	Saint Paul	Print/tin frame	18 x 18	Rio Arriba Workshop	1870-95
RU 010	Saint Vincent de Paul	Print/tin frame	19 dia.	New Mexico	1890-1910
RU 011	Nuestra Señora de Guadalupe	Print/tin frame	20 x 15.2	Rio Arriba Workshop	1870-95
RU 012	Santo Niño de Atocha	Oil on tin	18 x 13	Mexico	c. 1890
RU 013	Santo Niño de Atocha	Retablo	14 x 11	Follower of José Aragon	1840-55
RU 014	San Gerónimo	Retablo	34 x 14	Pedro Fresquis or a follower	1785-1830
RU 015	Maria von Guadeloupe	Print/tin frame	32 x 26.4	Rio Arriba Workshop	1870-95
RU 016	Varon de Dolores/Arma Christi	Oil on tin	26 x 17.5	Mexico	c. 1910
RU 017	Santa Rita de Casia	Fabric	33 x 25	Carson Group	1931-45
RU 018	Crucifijo	Bulto	63 x 32 x 9	Pedro Fresquis	1785-1830
RU 019	Nuestra Señora	Bulto	28 x 6.1 x 6	José Aragon/School of	1820-1835
RU 020	Santa Gertrudis	Retablo	30 x 18	AJ Santero	c. 1822
RU 021	San Francisco de Asís	Retablo	16.4 x 13.3	Jorge Sánchez	c. 1960
RU 022	San Jorge	Bulto	19 x 18 x 11	Luis Aragon	1972
RU 023	San Roque	Retablo	15 x 9	Tomás Burch	1968

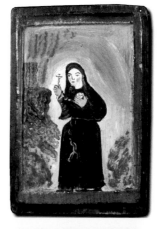

From top: RU 003. Santa Rita de Casia [lost]. Retablo. 14 x 20. José de Gracia Gonzales. 1865-1900.
RU 004. Unknown male saint. Retablo. 19 x 15. José Aragon. 1820-35.

67

RU 024	Squirrel	Wood item	9 x 25	José Mondragon	1967
RU 025	Crucifijo	Straw piece	27 x 20	Mexico	c. 1970
RU 026	San Ramón Nonato	Retablo	40.5 x 23.5	Cándido García	1973
RU 027	San Pascual Bailon	Retablo	25 x 18	Edmund Navrot	1976
RU 028	San José Patriarca	Retablo	89 x 29	Jorge Sánchez	1973
RU 029	Ángel Guardián	Bulto	20 x 13.5 x 8	Luis Aragon	1972
RU 030	Penitente matraca	Wood item	24.5 x 29.5 x 8	Max Vigil	1934
RU 031	San Benito de Palermo	Oil on tin	35.5 x 25.5	Mexico	c. 1910
RU 032	San José Patriarca	Bulto	24.5 x 9.7 x 8	José Aragon	1820-35
RU 033	San Isidro Labrador	Bulto	27 x 43 x 17	Luis Aragon	1973
RU 034	San Francisco de Asís	Bulto	32 x 11 x 8	George T. López	1974
RU 035	Tree of Life / Nativity / candelabrum	Pottery	25 x 27 x 8	Mexico	1974
RU 036	Cruz	Straw-inlay	46 x 15	Gilberto Espinosa	1974
RU 037	San Lorenzo	Print/tin frame	14 x 11	Mexico	c. 1890
RU 038	San Juan Bautista	Bulto	26 x 12 x 12	Luis Aragon	1974
RU 039	Santa Inés del Campo	Bulto	23 x 11 x 7	Luis Aragon	1974
RU 040	Cruz	Wood item	21 x 12	George T. López	1974
RU 041	Santo Niño de Atocha	Oil on tin	18.5 x 25.5	Mexico	1896
RU 042	Niño Jesus La Huida a Hipto	Bulto	20 x 30 x 12	Luis Aragon	1975
RU 043	San Ramón Nonato	Painting	43 x 32	Gilberto Espinosa	1966
RU 044	Milagro of a leg	Metal item	3.4 x 1.1	Mexico	c. 1900
RU-IC 045	Crucifijo	Bulto	67 x 36 x 15	Santero of Delicate Crucifixes	1810-30
RU 046	Nuestra Señora de los Dolores	Oil on canvas	29 x 22	Mexico	c. 1875
RU 047	Altar de morada	Wood item	117 x 249 x 25.4	Cuba, NM	c. 1920
RU 048	San Antonio de Padua	Print/tin frame	44 x 39	Taos Serrate Tinsmith	1870-1905
RU 049	Cristo Crucificado	Print/tin frame	42 x 36	New Mexico	c. 1880

From top: RU 013. Santo Niño de Atocha.
Retablo. 14 x 11. Follower of José Aragon. 1840-
55.
RU 019. Nuestra Señora. Bulto. 28 x 6.1 x 6.
José Aragon/School of. 1820-1835.

RU 050	Chimayó weaving	Fabric	37 x 75	Ortega Weaving Shop	1975
RU 051	Nuestra Señora de la Soledad	Oil on canvas	66 x 45	Mexico	1725-50
RU 052	Nuestra Señora de los Dolores	Bulto	61 x 26 x 20	Molleno/Follower of	1800-40
RU 053	San Rafael Arcángel	Bulto	33 x 18 x 18	George T. López	1977
RU 054	Santa Rita de Casia	Retablo	45 x 27	School of José Aragon or Quill Pen Follower	1830-40
RU 055	Carreta de la Muerte	Bulto	63 x 103 x 38	George T. López	1977
RU 056	Two milagros	Metal item	1 x 3.1	Mexico	c. 1950
RU 057	Cruz de Misión	Wood item	70.8 x 45.2	Mexico	1904
RU 058	Nuestra Señora de la Pma Concpn	Bulto	38 x 17 x 14	Mexico	c. 1790
RU 059	Crucifijo	Bulto	38 x 28	George T. López	1978
RU 060	San Pedro	Bulto	22 x 11 x 8	New Mexico	c. 1960
RU 061	Unknown male saint	Bulto	27 x 12 x 6	New Mexico	c. 1960
RU 062	Aspen art	Wood item	53.5 x 21	Juan Morales	1910
RU 063	Crucifijo	Bulto	52 x 31	Nolie Mumey	1979
RU 064	Nuestra Señora	Bulto	32 x 10 x 5	Michael Salazar	1979
RU 065	San Antonio Abad	Print/tin frame	22.7 x 15.4	Mexico	c. 1875
RU 066	Crucifijo de Esquipulas con angel	Bulto	75 x 47	Antonio Molleno	1800-40
RU 067	Nuestra Señora de Guadalupe	Print on panel	46 x 29.5	Nathaniel Currier	c. 1850
RU 068	San Juan Nepomuceno [traded]	Retablo	15.4 x 8.2	José Benito Ortega	1880-1907
RU 069	Santa Librada	Bulto	24 x 10 x 7	José Marcos García	1980
RU 070	San Juan Nepomuceno en nicho	Bulto	13.5 x 5.3 x 5.3	northern Mexican provincial	c. 1890
RU 071	Santo Niño de Atocha	Retablo	17.5 x 13.8	Rafael Aragon/School of	1820-70
RU 072	La Verónica con el Divino Rostro	Retablo	40 x 23	Alex Ortiz	1981
RU 073	Penitente badge	Fabric	16 x 16.5	Manufactured, U.S.	c. 1970
RU 074	Chispa or eslabon/strike-a-light	Metal item	10.3 x 3 x 0.7	Mexico	c. 1890
RU 075	Four milagros	Metal item	4 x 1	Mexico	c. 1950

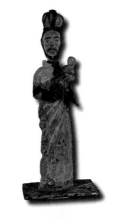

From top: RU 032. San José Patriarca. Bulto. 24.5 x 9.7 x 8. José Aragon. 1820-35.
RU 054. Santa Rita de Casia. Retablo. 45 x 27. School of José Aragon (1830-40) or Quill Pen Follower (1871-80).

69

From top: RU 059. Crucifijo. Bulto. 38 x 28.
George T. López. 1978.
RU 072. La Verónica con el Divino Rostro.
Retablo. 40 x 23. Alex Ortiz. 1981.

RU 076	Crucifijo	Pen drawing	43 x 26	New Mexico	1982
RU 077	Mary's heart-pierced—sword	Metal item	11 x 9.5 x 1.5	Mexico	c. 1950
RU 078	Nuestro Padre Dios	Retablo	28.5 x 19	Don & Marie Romero Cash	1982
RU 079	San Cristóbal	Retablo	28 x 15	Carlos Santistevan	1981
RU 080	San Ignacio	Print/tin frame	20.5 x 17.8	Santa Fe Federal	1840-70
RU 081	Carreta de la Muerte	Bulto	16.5 x 8.6 x 10.5	Kenneth & Betha Mount	1982
RU 082	Nuestra Señora de San Juan de los Lagos	Retablo	21 x 14	Antonio Molleno	1820-40
RU 083	Almud	Wood item	25 x 31 x 13.5	Socorro del Sur, TX	c. 1890
RU 084	Cruz	Straw-Inlay	33.5 x 25.2 x 7	Mexico	1810-25
RU 085	San Antonio de Padua	Bulto	19 x 6 x 4.3	Fray Andrés García	1748-78
RU 086	Tin Frame	Metal item	65.5 x 55.5	Mexico	1900-30
RU 087	Santo Niño de Atocha	Retablo	18 x 13.8	Irene Martínez Yates	1984
RU 088	Santo Niño de Praga (?)	Bulto	17 x 4.3 x 4	Santo Niño Santero	1830-50
RU 089	Dress	Fabric	17 x 16	New Mexico	c. 1920
RU 090	Cruz	Wood item	13.8 x 7.3 x .5	George T. López	1984
RU 091	Nuestra Señora del Carmen	Retablo	28.7 x 19.6	Antonio Molleno	1800-20
RU 092	Cruz	Wood item	30.8 x 10.5	Jémez Pueblo	1984
RU 093	Cruz	Straw-Inlay	14 x 6.4 x 0.8	Elmer Leon	1984
RU 094	Tin Nicho	Metal item	31.5 x 26.5 x 6.8	Mexico	c. 1910
RU 095	Nuestra Señora de los Dolores	Oil on canvas	28 x 20.3	Mexico	c. 1840
RU 096	Cruz	Wood item	25.4 x 51.4 x 2.3	New Mexico	c. 1910
RU 097	Crucifijo	Bulto	23 x 56 x 7.3	José Benito Ortega	1880-1907
RU 098	Cruz	Wood item	17.7 x 8.2 x 1	Sabinita Lopez Ortiz	1985
RU 099	San Ignacio	Retablo	59.5 x 41	Cándido García	1975
RU 100	San Juan Francisco Regis	Retablo	59.5 x 41	Jorge Sánchez	1975
RU 101	Adán y Eva	Bulto	89.4 x 33 x 16	Mexico	1974

RU 102	Crucifijo	Bulto	77 x 47 x 14	Luis Aragon	1975
RU 103	Nuestra Señora de los Dolores	Bulto	47.5 x 17.5 x 8	Luis Aragon	1975
RU 104	Two ramilletes/paper flowers	Paper item	7.5 to 8.3	Mexico or New Mexico	c. 1850
RU 105	La Santísima Trinidad	Retablo	41 x 29.5	Symeon Carmona	1983
RU 106	Sagrada Familia	Oil on tin	35.7 x 25.5	Mexico	c. 1870
RU 107	San Francisco de Asís	Bulto	20.8 x 7.8 x 9	Bob O'Rourke	1986
RU 108	Fabric shoulder patch	Fabric	12.3 x 10	Manufactured, U.S.	c. 1980
RU 109	Santo Niño de Praga	Bulto	34 x 24 x 11	Philippines	c.1985
RU 110	Nuestra Señora de los Dolores	Retablo	26 x 18.5	A.J. Santero	c. 1822
RU 111	San Acacio	Bulto	43 x 28.7 x 8	Charlie Carrillo	1987
RU 112	San José Patriarca	Retablo	22.5 x 13.5	Charlie Carrillo	1987
RU 113	San José Patriarca	Retablo	22.8 x 14.2	Estrellita de Atocha Carrillo	1987
RU 114	Cruz	Wood item	38.1 x 25.5 x 2	Juan and Georgiana Romero	1987
RU 115	Santo Niño de Atocha	Retablo	15 x 9.4	Mónica Sosaya Halford	1987
RU 116	Four milagros	Metal item	3, max side	Mexico	c. 1950
RU 117	San Francisco de Asís	Bulto	22 x 18 x 9.5	Ben Ortega	1987
RU 118	Cruz	Straw-Inlay	19.6 x 12.7 x 0.7	Jimmy E. Trujillo	1987
RU 119	Crucifijo	Straw piece	60 x 38.3	Mexico	c. 1970
RU 120	San Gabriel	Retablo	8.5 x 6.2	Rosina López de Short	1987
RU 121	Nuestra Señora del Refugio	Retablo	25 x 12	José Aragon /Arroyo Hondo	1820-70
RU 122	San Ignacio de Loyola [given]	Retablo	27 x 18	Charlie Carrillo	1988
RU 123	Cruz con los Arma Christi	Wood item	41 x 19 x 10.5	Colorado	c. 1920
RU 124	Cuaderno of alabados	Paper item	17 x 10.5	Bonifacio Flores	1953
RU 125	Tiniablero/candelabrum	Wood item	174.5 x 95 x 49.6	New Mexico	c. 1915
RU 126	Devotional item				
RU 127	Cruz en cruz	Wood item	164.3 x 102	New Mexico	c. 1920

From top: RU 078. Nuestro Padre Dios. Retablo. 28.5 x 19. Don & Marie Romero Cash. 1982.
RU 079. San Cristóbal. Retablo. 28 x 15. Carlos Santistevan. 1981.

From top: RU 082. Nuestra Señora de San Juan de los Lagos. Retablo. 21 x 14. Antonio Molleno. 1820-40.
RU 120. San Gabriel. Retablo. 8.5 x 6.2. Rosina López de Short. 1987.

RU 128	Cajon del Santo Entierro	Wood item	67 x 149 x 47	New Mexico	c. 1920
RU 129	Santo Niño	Bulto	12 x 5.6 x 3.8	Laguna Santero?	1790-1809
RU 130	La Anima Sola	Bulto	19.8 x 5.7 x 3.3	Puerto Rico	c. 1890
RU 131	Santo Niño	Bulto	12.5 x 5 x 4.5	Follower of José Aragon	1830-45
RU 132	Santo Niño de Atocha	Carved relief	34.5 x 23.4	Efren Martínez	1938
RU 133	Santa Rosalía	Bulto	27 x 9.8 x 6.5	Antonio Molleno	1800-40
RU 134	San Juan Nepomuceno	Retablo	44.4 x 16.4	Antonio Molleno	1800-20
RU 135	San Ignacio de Loyola	Retablo	26.5 x 16.5	Arroyo Hondo Santero	1820-70
RU 136	Nuestra Señora del Rosario	Bulto	30 x 5.8 x 4	John Tollardo	c. 1989
RU 137	San Ignacio Loyola/San FrancEsco Xavier	Metal item	4.9 x 4	Italy	c. 1750
RU 138	Nuestra Señora	Bulto	24 x 8.6 x 4.4	New Mexico	c. 1960
RU 139	San José Patriarca	Bulto	45 x 15 x 13	Laguna Santero	1790-1809
RU 140	San Antonio de Padua	Bulto	38 x 10.5 x 11.8	Rafael Aragon/Santo Niño Santero (body), José Benito Ortega (head), José de Gracia Gonzales (infant)	1820-1907
RU 141	Sagrado Corazón	Stone item	7.4 x 6.8 x 2.2	New Mexico	c. 1895
RU 142	Santiago	Bulto	37.5 x 27.5 x 10.5	Malcolm Withers	1990
RU 143	Nuestra Señora de Guadalupe	Retablo	23.4 x 15.4	Antonio Molleno	1830-40
RU 144	San Ignacio de Loyola	Retablo	33.3 x 25	Rafael Aragon	1820-65
RU 145	Calvario con los Arma Christi	Bulto	53.7 x 14.4 x 8.1	Possibly central Europe	c. 1910
RU 146	San Francisco de Asís	Retablo	30 x 15.8	Roán Miguel Carrillo	1991
RU 147	Santa Bárbara	Bulto	60.8 x 18.7 x 16.1	Horacio Váldez	1991
RU 148	Nuestra Señora Amable/Madre Amable	Bulto	29.8 x 11.5 x 8.5	Philippines	c. 1890
RU 149	Nuestra Señora de la Purísima Concepción	Bulto	30 x 10 x 7.5	Philippines	c. 1890
RU 150	Nuestra Señora (de la Puris Conc?)	Bulto	32.1 x 8.3 x 6	Philippines	c. 1890
RU 151	Nuestra Señora de la Purísima Concepción	Bulto	30.9 x 8.6 x 7	Philippines	c. 1890
RU 152	Holy water font	Wood item	43 x 17.4 x 17.6	Eastern U.S.	c. 1890
RU 153	San Miguel Arcángel	Bulto	38.6 x 23 x 10	Don Headlee	1989

RU 154	Nuestra Señora	Retablo	26 x 16	Provincial Academic II	1748-78
RU 155	Cuaderno of alabados	Paper item	17.8 x 11	Tomás Pacheco	c. 1945
RU 156	Ángel Guardián	Bulto	30 x 25 x 5	Michael Ortega	1992
RU 157	San Ignacio de Loyola	Retablo	21.7 x 13.9	Jacqueline Nelson	1992
RU 158	Santa Lucía	Retablo	26.2 x 14.2	M.J. García	1992
RU 159	Kaolin tablet	Pottery	6 x 3.9 x 1.4	Guatemala	1992
RU 160	Sagrado Corazón	Retablo	19.4 x 18.9	Rafael Aragon	1820-62
RU 161	Nuestra Señora de Guadalupe	Retablo	35.8 x 21.6	El Salvador	1992
RU 162	Tiber and Castel Santangelo, etc.	Print/bultos	44 x 69.8 x 11	New Mexico	c. 1980
RU 163	San Ignacio de Loyola [given]	Bulto	57 x 19.7 x 26	Alcario Otero	1992
RU 164	Santa Librada	Bulto	49.8 x 29 x 7	Frank Brito	1992
RU 165	Tiny bird	Wood item	2.7 x 5 x 2.5	Leo Salazar	1990
RU 166	San Felipe Neri	Bulto	43.8 x 9.8 x 7.8	Max Roybal	1992
RU 167	San Ramón Nonato	Print	20.5 x 15.8	Probably Mexico	c. 1960
RU 168	El Buen Pastor	Bulto	46.5 x 18 x 13.5	Patrocinio Barela	1931-34
RU 169	Guia de Jesús Crucificado	Oil on canvas	95 x 69.5	José de Gracia Gonzales	1865-1900
RU 170	El Rey Mago ó San Clemente Papa	Bulto	26 x 9.6 x 7.6	Southern New Mexico	c. 1790
RU 171	Woman in mourning	Painting	43.2 x 29.2	Muriel Sibell Wolle	c. 1960
RU 172	Men carrying maderos	Painting	45.7 x 35.6	Muriel Sibell Wolle	c. 1960
RU 173	Man on cross	Painting	50 x 33.7	Muriel Sibell Wolle	c. 1960
RU 174	Persons approaching Gothic(!!?) chapel	Painting	48.3 x 31.8	Muriel Sibell Wolle	c. 1960
RU 175	San Ignacio de Loyola	Retablo	23.1 x 17.9	José Raul Esquibel	1992
RU 176	El Divino Rostro	Retablo	34.5 x 24.8	Elmer Shupe	c. 1955
RU 177	San Juan Bautista	Oil on tin	40.2 x 28.2	Mexico	c. 1880
RU 178	Nuestra Señora de la Soledad	Bulto	44.4 x 13.5 x 11	Howard Shupe	1992
RU 179	San Isidro Labrador	Hide painting	22.5 x 15	Mary Jo and George Martínez	1993

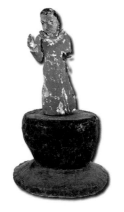

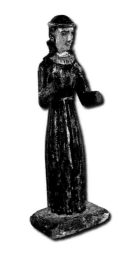

From top: RU 131. Santo Niño. Bulto. 12.5 x 5 x 4.5. Follower of José Aragon. 1830-45. RU 133. Santa Rosalía. Bulto. 27 x 9.8 x 6.5. Antonio Molleno. 1800-40.

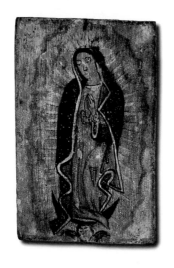

From top: RU 134. San Juan Nepomuceno. Retablo. 10.4 x 16.4. Antonio Molleno. 1800-20.
RU 143. Nuestra Señora de Guadalupe. Retablo. 23.4 x 15.4. Antonio Molleno. 1830-40.

74

RU 180	San Acacio	Retablo	20.9 x 16	Rafael Aragon/Follower of	1830-60
RU 181	San Cristóbal	Retablo	19.7 x 12.4	Frank Applegate	1928
RU 182	Diligencia con dos caballos	Wood item	50.7 x 20.4 x 23.5	Colorado	c. 1980
RU-R&BS 183	Jesús Nazareno	Bulto	106.7 x 38.1 x 26.7	José Aragon/José Benito Ortega	1820-1907
RU-R&BS 184	Crucifijo	Bulto	119.4 x 78 x 19.5	Juan Ramón Velásquez	1870-1900
RU-R&BS 185	Varon de Dolores	Bulto	112 x 26.7 x 12.7	José Inés Herrera	1890-1910
RU-R&BS 186	Santa Rita de Casia	Retablo	44.5 x 26.7 x 3.2	José Aragon	1820-35
RU-R&BS 187	San Ramón Nonato	Retablo	21.6 x 17.1	18th Century Novice	1780-1800
RU 188	San Ramón Nonato	Retablo	26 x 15	José Aragon	1820-35
RU 189	San José Patriarca	Retablo	16.4 x 13.5	Jorge Sánchez	c. 1960
RU 190	Dios Padre	Retablo	13.8 x 8.7	Orlando Romero	c. 1980
RU 191	Nuestra Señora del Rosario	Print	38.2 x 31	Mexico	c. 1930
RU 192	Nuestra Señora de los Angeles de México	Metal item	4 x 2.6	F. Gordillo	1806-23
RU 193	Four-real coin	Metal item	3.5 dia.	Spain or New Spain	1788
RU 194	Crucifix	Bulto	6.2 x 5.1 x 1	El Salvador	c. 1990
RU 195	Santa Gertrudis la Magna	Retablo	80 x 47	Antonio Molleno	1835-50
RU-R&BS 196	Cuaderno of alabados	Paper item	15 x 9	Tobías Salazar	c. 1950
RU-JM 197	Cruz	Bulto	51.5 x 25.7 x 9	George T. López	1937
RU-JM 198	Tree of Life	Bulto	25 x 34.5 x 14	Benita Reino de López	c. 1950
RU-JM 199	Nuestra Señora del Rosario	Bulto	53.4 x 15.4 x 15.8	José Aragon/José Benito Ortega	1820-1907
RU 200	San Pedro Apostol	Bulto	17.1 x 14.6 x 11.5	Carlos Santistevan	1993
RU 201	Tree of Life	Retablo	64 x 56.6	Roberto Gonzales	1993
RU 202	San Ignacio de Loyola	Bulto	76.5 x 40.3 x 31.5	Alcario Otero	1994
RU 203	Angelito con cáliz	Bulto	23.5 x 7.7 x 13.4	José Benito Ortega	1880-1907
RU 204	La Santísima Trinidad	Print	23.3 x 17	Mexico	c. 1895
RU 205	Cristo Crucificado	Retablo	40 x 22.8	New Mexico	1988

RU 206	Sagrada Familia	Retablo	41 x 61.1	Jacobo de la Serna	1994
RU 207	San Gerónimo	Print	26.6 x 19.2	Louie Ewing	1941
RU 208	Nuestra Señora de San Juan de los Lagos	Gesso relief	36.9 x 21.4 x 3.8	New Mexico	c. 1800
RU 209	San Jorge	Carved relief	13 x 16.7 x 5.1	Celso Gallegos	1910-1943
RU 210	Nuestra Señora del Pueblito de Querétaro	Retablo	36.4 x 21.7	Quill Pen Santero	1830-50
RU 211	San Ignacio de Loyola (?)	Bulto	31 x 11.4 x 11.5	New Mexico	c. 1830
RU 212	Santa Rosalía	Retablo	35 x 23.2	Nicholas Herrera	1994
RU 213	Santo Tomás Apóstol	Retablo	35 x 23.2	Nicholas Herrera	1994
RU 214	Nuestra Señora de los Dolores	Retablo	25.8 x 18.4	David Nabor Lucero	1994
RU 215	Jesús Nazareno, cabeza de	Bulto	22.2 x 13 x 13	Santiago Gallegos	1930-40
RU 216	San Ignacio de Loyola	Retablo	24.4 x 13.5	Dion Hattrup de Romero	1994
RU 217	Sagrada Familia	Bulto	15 x 19.4 x 8.6	José Eurgencio López	1994
RU 218	Nuestra Señora de los Dolores	Oil on canvas	42.8 x 33.5	Mexico	c. 1860
RU 219	Jesus der Erloser [Redeemer/Ransom]	Print/tin frame	33 x 27	Valencia Red & Green Tinsmith	1870-1900
RU 220	St Joseph der Vater des Waifen	Print/tin frame	33 x 28	Valencia Red & Green Tinsmith	1870-1900
RU 221	Nuestra Señora de Guadalupe	Print	33.6 x 16.5	Louie Ewing	1941
RU 222	Kerchief slide	Bone	7.9 x 3.5 x 2.3	Floyd Trujillo	1994
RU 223	Jesús Nazareno, cabeza de	Retablo	50 x 28.5	Al Florence	1994
RU 224	Devotional item				
RU 225	Arma Christi cum Animis	Oil on copper	41.9 x 33	Mexico	c. 1830
RU 226	Crucifix	Ivory/wood	22.2 x 11.2 x 3.8	Portugal/India	c. 1850
RU 227	Censer	Metal item	105.8 x 10.2 x 10.2	Mexico	c. 1850
RU 228	Santo Niño de Atocha	Bulto	18.6 x 7.3 x 7.3	Mexico	1830-50
RU 229	Cruz	Fabric	41.0 x 38.1	Mexico	c. 1870
RU 230	Santa Inés de Roma	Oil on copper	38.1 x 30.5	Mexico	c. 1790
RU 231	Paño (handkerchief)	Fabric	42.6 x 42.6	Jimmy Martínez	c. 1990

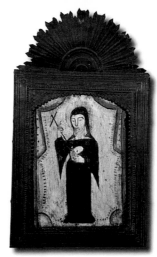

From top: RU 154. Nuestra Señora. Retablo. 26 x 16. Provincial Academic II. 1748-78. RU-R&BS 186. Santa Rita de Casia. Retablo. 44.5 x 26.7 x 3.2. José Aragon. 1820-35.

From top: RU 188. San Ramón Nonato.
Retablo. 26 x 15. José Aragon. 1820-35.
RU 207. San Gerónimo. Print. 26.6 x 19.2.
Louie Ewing. 1941.

RU 232	The Night of Betrayal	Print/tin frame	22 x 22	Valencia Red & Green Tinsmith	1870-1900
RU 233	Paño	Fabric	40 x 40	New Mexico	c. 1985
RU 234	Devotional item				
RU 235	San Pedro	Retablo	19 x 13.5	Benjamin A. Gabaldon	1995
RU 236	San Miguel Arcángel	Bulto	38 x 7.3 x 12.7	Provincial Academic II	c. 1800
RU 237	Niño	Bulto	10.9 x 5 x 5.6	Northern Mexico	c. 1860
RU 238	Adán y Eva	Retablo	46 x 27.4	Charlie Carrillo	1994
RU 239	Ramilletes	Paper item	58 and 63 x 9	Estrellita and Roán Carrillo	1994
RU 240	San Miguel Arcángel	Retablo	22.5 x 15.1	Rafael Aragon/School of	1830-60
RU 241	Nuestro Señor de Esquipulas in nicho	Bulto	55.6 x 29.2 x 29.4	Cecile Turrietta	1995
RU 242	Intérieur de Nazareth Une fleur á St Joseph	Print/tin frame	9.1 dia.	Valencia Red & Green Tinsmith	1870-1900
RU 243	Santo Niño de Atocha	Metal item	12.7 x 8.9 x 1.3	Manufactured, Mexico	c. 1890
RU 244	La Milagrosa Imagen del Señor de Esquipulas	Oil on tin	38.1 x 32.4	Mexico	c. 1850
RU 245	Guadalupe episode	Oil on canvas	38.7 x 29.2	Mexico	c. 1865
RU 246	Book stand	Wood item	20 x 28.1 x 25.6	New Mexico	1940-60
RU 247	Nacimiento (crib scene)	Bulto	29.6 x 34.4 x 20.4	Luis Aragon	c. 1970
RU 248	Santo Niño de Atocha	Print/tin frame	7.9 x 5.3	Mexico	1995
RU 249	Suite of "Saints of the New World" prints	Print	27.8 x 20.5 each	Catherine Ferguson	1995
RU 250	Nacimiento (crib scene)	Retablo	41.5 x 28.5	Ernie Lujan	1995
RU 251	San Lorenzo	Retablo	50 x 35	James M. Córdova	1995
RU 252	San Acacio	Retablo	30.3 x 22.8	Frankie Nazario Lucero	1995
RU 253	Santo Niño de Atocha	Retablo	20.8 x 13.1	New Mexico	c. 1985
RU 254	Owl	Wood item	13.5 x 4.7 x 4.5	George T. López	
RU 255	Nuestra Señora con flores	Painting	37 x 25.5	Virginia Parks Brown	
RU 256	Nuestra Señora de los Dolores	Retablo & pouch	10.8 x 8.2	Charlie and Debbie Carrillo	1995
RU 257	San Juan Bautista	Retablo	44.7 x 28.5	Andrew T. Johnston	1955

RU 258	Crucifix (Arma Christi)	Wood item	36.4 x 19 x 3.7	José Dolores López	1930-38
RU 259	San ?pope and martyr?	Retablo	13 x 11	Earl Noell	c. 1970
RU 260	Cruz	Wood item	42.8 x 30	Earl Noell	c. 1972
RU 261	Cruz de Santiago	Wood item	6 x 7	José Raul Esquibel	1995
RU 262	San Luis Gonzaga	Retablo	35.7 x 22	Charlie Carrillo	1991
RU 263	Santo Niño de Atocha	Retablo	34 x 24.5	Elmer Shupe	c. 1975
RU 264	Sagrado Corazon	Print/tin frame	17.8 x 15	New Mexico	c. 1875
RU 265	Station 8	Print/tin frame	23.5 x 21.2	New Mexico	c. 1875
RU 266	Station 4	Print/tin frame	22 x 18.8	New Mexico	c. 1875
RU 267	Station 11	Print/tin frame	26.8 x 21.9	New Mexico	c. 1875
RU 268	Station 3, 7, or 9	Print/tin frame	24.4 x 20.4	New Mexico	c. 1875
RU 269	Immaculate Heart	Print/tin frame	31.4 x 26	New Mexico	c. 1875
RU 270	San Pascual Bailon	Print/tin frame	30.9 x 25	New Mexico	c. 1875
RU 271	Madre Purísima-Mater Purissima	Print/tin frame	25 x 21.1	Valencia Red & Green Wrkshp	1885-1910
RU 272	Sagrada Familia	Print/tin frame	5.5 x 4.4	New Mexico	c. 1875
RU 273	Escapulario de NPJN	Fabric	17 x 11.8	Mexico	c. 1990
RU 274	Notre Dame de Lourdes	Bulto	33.4 x 10.8 x 7	France	c. 1880
RU 275	Cruz	Fabric/tin frame	42.4 x 34.6	Rita and Juan Martínez	1995
RU 276	Pito	Metal item	32.3 x 1.7 x 1.7	Southern Colorado	c. 1900
RU 277	Cruz con Sagrado Corazón	Bulto	55 x 31.8 x 14.5	Gustavo Victor Goler	1996
RU 278	Sagrado Corazón	Metal item	9.3 x 6.5	Debbie Carrillo	1995
RU 279	Farol (lantern)	Metal item	26.7 x 10.7 10.7	Ted Arellanes	1995
RU 280	San Francisco de Asís	Bulto	15 x 7 x 5	Northern Mexico/Rio Abajo	c. 1780
RU 281	San Juan Evangelista	Bulto	45.4 x 20.2 x 7	New Mexico	c. 1910
RU 281a	Llano de Abeyta morada	Painting	10.3 x 15.1	Bill Tate	c. 1980
RU 282	San Longino y Crucifijo	Bulto	114.3 x 58.4 x 56	Félix López	1996
RU 283	San Ignacio de Loyola	Gesso relief	59.7 x 45.7	Charlie Carrillo	1996

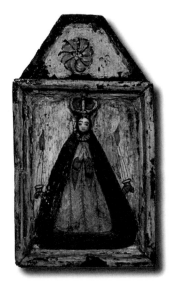

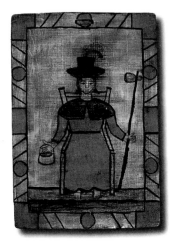

From top: RU 208. Nuestra Señora de San Juan de los Lagos. Gesso relief. 36.9 x 21.4 x 3.8. New Mexico. c. 1800.
RU 263. Santo Niño de Atocha. Retablo. 34 x 24.5. Elmer Shupe. c. 1975.

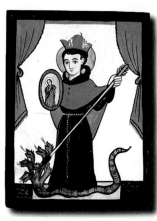

RU 284	Santo Niño de Atocha	Retablo	24.5 x 17.5	Al Florence	1996
RU 285	Omnipresencia de Dios	Print/tin frame	47.5 x 33.5	Valencia Red-&-Green Wkshp	1885-1910
RU 286	San Buenaventura	Retablo	31.4 x 24.4	Charlie Carrillo	1996
RU 287	Las Cinco Llagas — The Five Wounds	Gesso relief	40 x 29.1	Charlie Carrillo	1994
RU 288	Santa Marina de Jesús	Bulto	29.7 x 10.3 x 6.8	Mexico or South America	c. 1920
RU 289	Ángel Guardián	Bulto	12 x 17 x 6.3	Antonio Ortega	1994
RU 290	Nuestra Señora de los Dolores	Retablo	32 x 20	Jacobo de la Serna	1996
RU 291	San Pedro	Hide painting	19.5 x 16	New Mexico	
RU 292	Santiago	Hide painting	21 x 19.5	New Mexico	
RU 293	Triple Rostro/Three Faces of Jesus	Retablo	25.2 x 45.8	Alcario Otero	1993
RU 294	Cruz con Sagrado Corazón	Bulto	29.9 x 20 x 4	Ernie Lujan	1996
RU 295	San Antonio de Padua	Print	29 x 21.2	Martha Ann Walker	1955-56
RU 296	Nª Señora crowned in treetop	Print	24.4 x 18.5	Mexico	c. 1915
RU 297	San Vicente Ferrer	Retablo	38.5 x 14.5	Frank "Pancho" Alarid	1987
RU 298	Santa Verónica con el Rostro	Print	30.3 x 20.5	E. Boyd/WPA Artists	1939-40
RU 299	San Ignacio de Loyola	Retablo	35.8 x 23.7	Jorge Sánchez	1965
RU 300	Aurora Altar Screen	Altar Screen	279.4 x 182.9 x 45.7	John Olivas & other Santeros del Norte	1996

From top: RU 281a. Llano de Abeyta morada.
Painting. 10.3 x 15.1. Bill Tate. c. 1980.
RU 286. San Buenaventura. Retablo. 31.4 x
24.4. Charlie Carrillo. 1996.

Categories of Santos

Index by Subjects

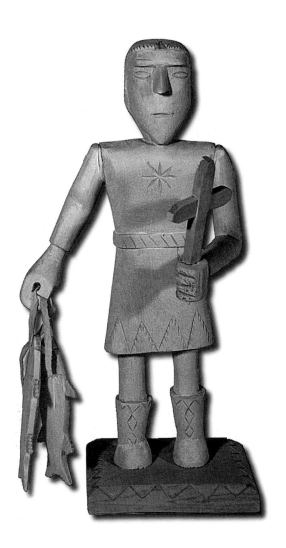

RU 053. San Rafael Arcángel. Bulto. 33 x 18 x 18. George T. López. 1977.

Index by Artists

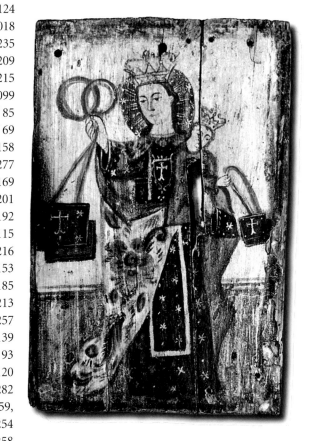

RU 091. Nuestra Señora del Carmen. Retablo. 28.7 x 19.6. Antonio Molleno. 1800-20.

Special Acknowledgements

I would like first of all to thank my Aunt Clare Loyola Harder, the Regis Jesuit Community, Regis University, and the Immaculate Conception Jesuit Community in Albuquerque.

Santeros who donated their own work to the Regis Collection were Charles and Debbie Carrillo, Gilberto Espinosa, José Raul Esquibel, Al Florence, Ben Gabaldon, Roberto Gonzales, George and Silvianita López, Ernie Lujan, Juan and Rita Martínez, Nolie Mumey, M.D., Jacqueline Nelson, Bob O'Rourke, Leo Salazar, Jorge Sánchez, Jacobo de la Serna, and Irene Martínez Yates.

My brethren in the clergy who showed me their fraternal generosity were Fathers James Moore and Sotero Sena of the Archdiocese of Santa Fe and Jesuits Joe Browning, Tim Cronin, Tom Cummings, Fillmore Elliot, Tom Jost, Pierre Landry, Bill Mayer, Bill McNichols, Jack Oster, Alvin Pilié, Frank Renfroe, Tom Scherman, Jack Teeling, and Josef Venker.

Other generous persons were Mr. and Mrs. Juan M. Aragon, Barbe Awalt and Paul Rhetts, Mr. and Mrs. Fred Birner, Nancy Robb Briggs, Catherine Brogan, Rosalie Casaus, Mr. and Mrs. Arthur Castillo, Mr. and Mrs. Jack Cheshire, Mr. and Mrs. Paul Choc, Sr., Jean and Greg Colle, Purita David, Mr. and Mrs. Phillip Freeman, Jim Gerken, Dick Hullett, Robert Kerr, David Joe López, Mr. and Mrs. Tom Lyons, Lolly Martin, Mr. and Mrs. Kenneth Mount, Mr. and Mrs. Nat Owings, Juana María Pecos, Georgine Preston, Mr. and Mrs. Agustín Quintana, Mr. and Mrs. Tom Rollins, Carlos Santistevan, Carolyn and Margaret Schmidt, Dorothy Shaw, Mr. and Mrs. Kurt Stephen, Cecile Turrietta, Michael Váldez, Mr. and Mrs. Carmen Vigil, Sr., and Louise Shupe Wadley.

To them all:

Eterna día les dé Dios — May God grant them the eternal Day of the Lord.

Regis was fortunate to acquire the altar screen from the 1996 Santeros del Norte exhibit at the Aurora History Museum. Loosely modeled on the twelve-artist reredos at El Rancho de las Golondrinas near Santa Fe, the Aurora collaboration is thought to be the first santero altar screen created in Colorado. Several of the panels echo the state's scenery, with San Isidro Labrador, San Ignacio de Loyola, and San Francisco de Asís posing against Front Range or San Luis Valley backgrounds. St. Frances Xavier Cabrini worked in Denver at the orphanage of her order that formerly stood at 49th and Federal.

Ten santeros contributed to the project, with Peter Faris of the Aurora museum as the original instigator, José Esquibel as the organizer, and John Olivas as the main designer and creator. The artists involved included Meggan R. De Anza, Teresa Duran, José Raul Esquibel, Ronn Miera, Gerónimo Olivas, John Olivas, Lucie Olivas, Carlos Santistevan, Jr., Catherine Robles-Shaw, and Paul Zamora. The altar screen in its present slightly-revised form will migrate back and forth between the St. John Francis Regis Chapel and the santo display in the Dayton Memorial Library, for it is both a sacred item and a work of art.

RU 300. Aurora Altar Screen. Altar Screen. 279.4 x 182.9 x 45.7. John Olivas & other Santeros del Norte. 1996.

Writings by Thomas J. Steele, S.J.

NEW MEXICAN STUDIES

New Mexican Spanish Religious Oratory: 1800-1900. Albuquerque, University of New Mexico Press, 1997.

"An Old New Mexican Retablo Shows Us a New Subject," *Tradición Revista* 1#3 (Fall 1996), pp. 39-41.

"The Early Santo Revival in Albuquerque: Santero Luis Aragon," *Tradición Revista* 1#2 (Summer 1996), pp. 45-47.

"Fray Angélico Chávez: In Memoriam," *Book Talk* 25 #3 (June 1996), pp.1-2.

"Alburquerque in 1821: Padre Leyva's Descriptions," *New Mexico Historical Review* 70 (1995), pp. 159-78.

Santos and Saints. Santa Fe: Ancient City Press, 1994.

Folk and Church in Nineteenth-Century New Mexico. Colorado Springs: Hulbert Center for Southwest Studies, The Colorado College, 1993.

"Foreword" to Fray Angélico Chávez, *My Penitente Land.* Santa Fe: Museum of New Mexico Press, 1993.

"Church Buildings and Land in Old Albuquerque: In Celebration of the Bicentennial of the Present Church Structure, 1793-1993." Albuquerque: San Felipe Neri Church, 1993.

"The Virgin Mary and Her Images in Spanish Colonial Art." Denver: Denver Art Museum, 1993 (with Mary Armijo).

"Foreward" to Larry Frank, *New Kingdom of the Saints.*

Santa Fe: Red Crane Books, 1992.

Hispanic Los Aguelos and Pueblo Tsave-Yohs. Albuquerque: Southwest Hispanic Research Institute, 1992.

"Territorial Documents and Memories: Singing Church History," *New Mexico Historical Review* 67 (1992), pp. 393-413 (with Rowena A. Rivera).

"The Sad Poet of Ranchos de Albuquerque," *Traditions Southwest* 1 #1 (September 1989), pp. 38-40 (with Rowena A. Rivera).

"The View From The Rectory," in E.A. Mares,ed. *Padre Martínez: New Perspecitves* (Taos: Millicent Rogers, 1988), pp. 71-100.

(editor of) *The Life of Bishop Machebeuf.* Denver: Regis College, 1987 (with Ronald S. Brockway).

"The Hispanic Arts in Colorado," in "Hispanic Night at the Center" (January 31, 1987), pp. 3.

"Cofradía," *The World & I* 1 #8 (August 1986), pp. 148-61.

Penitente Self-Government: Brotherhoods and Councils, 1797-1947. Santa Fe: Ancient City Press, 1985 (with Rowena A. Rivera).

"Funciones of a Village," pp. 6-8 in Frederico Vigil, ed., *Funciones: Communal Ceremonies of Hispanic Life.* Albuquerque: Sagrada Arts Studio, 1983.

Works and Days: A History of San Felipe Neri Church, 1867-1895. Albuquerque: Albuquerque Museum, 1983.

"Albuquerque Parish Celebrates Centenary," *The*

Southern Jesuit 2 #3 (April 1983), pp. 11-15 (and cover).

"The Naming of Places in Spanish New Mexico," pp. 293-302 in Marta Weigle, ed., *Hispanic Arts and Ethnohistory in the Southwest.* Albuquerque: University of New Mexico Press, 1983.

Diary of the Jesuit Residence of Our Lady of Guadalupe Parish, Conejos, Colorado, December 1871-December 1875. Colorado Springs: Colorado College, 1982 (with Marianne L. Stoller and José B. Fernández).

Santos and Saints: The Religious Folk Art of Hispanic New Mexico. Santa Fe: Ancient City Press, 1982.

"St. Peter: Apostle Transformed Into Trickster," *Arche* 6 (1981), pp. 112-28 (with William J. Hynes).

"The Brief Career of the 'Healer,'" *Albuquerque Journal* "Impact" (November 11, 1980), pp.10-13.

"The Triple Rostro of Arroyo Seco," *Denver Post* "Empire" (April 8, 1979), pp. 23-25.

"The Death Cart: Its Place Among the Santos of New Mexico," *Colorado Magazine* 55 (1979), pp. 1-14 (and cover).

"The Spanish Passion Play in New Mexico and Colorado," *Historical Review* 53 (1978), pp.239-59.

Navajo Ceremonial Practice. Denver: Regis College, 1977 (revised 1985) (with Randolph Lumpp).

"Italian Jesuits and Hispano Penitentes," *Il Giornalino* 5 #1 (February 1978), pp. 11-17.

Holy Week in Tomé: A New Mexico Passion Play. Santa

Fe: Sunstone Press, 1976.

"The American Passion Play," *The Jesuit Bulletin* 55 #1 (March 1976), pp. 10-11.

"Peasant Religion: Retablos and Penitentes," pp. 123-139 in José de Onís, ed., *The Hispanic Contribution to the State of Colorado.* Boulder: Westview Press, 1976.

Santos and Saints: Essays and Handbook. Albuquerque: Calvin Horn Press, 1974.

"New Mexico Santero Art," *La Luz* 1 #8 (December 1972), pp. 22-24.

LITERARY STUDIES

Adducere II: The Faculty Lectures at Regis College of Regis University, 1987-1993. Denver: Regis University 1995 (co-editor)

Masterplots II: Poetry. Magill, 1992. (four poetry explications)

A Guidebook to Zen and the Art of Motorcycle Maintenance. New York: William Morrow Publisher, 1990 (with Ronald DiSanto).

Fraser Haps and Mishaps: The Diary of Mary E. Cozens. Denver: Regis College Press, 1990 (with Alice Reich).

"The Games of Life," in Margaret L. McDonald. ed., *Adducere,* Denver: Regis College, 1987. pp 50-56.

"Orality and Literacy in Matter and Form: Ben Franklin's *Way to Wealth*," *Oral Tradition* 2 #1 (January 1987), pp. 273-85.

"The Foundational Pattern of 'God's Grandeur,'" *Hopkins Quarterly* 12 (1985-86), pp. 80-82.

"Vertigo in History: The Threatening Tactility of 'Sinners in the Hands,'" *Early American Literature* 18 (1983-84), pp. 242-56 (with Eugene R. Delay).

"The Figure of Columbia: Phillis Wheatley Plus George Washington," *New England Quarterly* 54 (1981), pp. 264-66.

"Zen and the Art of Motorcycle Maintenance: The Identity of the Erlkonig," *Ariel* 10 #1 (January 1979), pp. 83-93.

"Seminar in Denver Explores Plains Indians' Religious Values," *National Jesuit News* 7 #9 (May 1978), p. 13.

(editor of) A.E. Housman, "Fragment of a Greek Tragedy," *Network* 2 (1974), pp. 18-21.

"Tom and Eva: Mrs. Stowe's Two Dying Christs," *Negro American Literature* 6 (1972), pp. 85-90.

"The Tactile Sensorium of Richard Crashaw," *Seventeenth-Century News*, 30 (1972), pp. 9-10.

"The Oral Patterning of the Cyclops Episode, *Odyssey* IX," *The Classical Bulletin* 48 (1972), pp. 54-56.

"Donne's Holy Sonnet XIV," *The Explicator* 29 (1971), #74.

"The Biblical Meaning of Mather's Bradford," *Bulletin of the Rocky Mountain Modern Language Association* 24 (1970), pp. 147-54.

"Literate and Illiterate Space: The Moral Geography of Cooper's Major American Fiction," *Dissertation Abstracts* 29 (1969), 4507 A.

Approaches to Literature. 5 volumes. Syracuse: L.W. Singer, 1967 (with Julian L. Maline, S.J., and James Berkley).

(translations of some of Martial's *Epigrammata)* in Garry Wills, ed., *Roman Culture: Weapons and the Man.* New York: George Braziller, 1966.

"For Teresa, Dying of Cancer" (poem), *Review for Religious* 24 (1965), pp. 273.

Prose and Poetry for Enjoyment. 5 volumes. Syracuse: L.W. Singer 1965 (with Julian L. Maline, S.J.).

Suggested Readings/Sources

1943 Mitchell A. Wilder and Edgar Breitenbach. *Santos: The Religious Folk Art of New Mexico.* Colorado Springs: Taylor Museum.

1946 E. Boyd. *Saints and Saintmakers.* Santa Fe: Laboratory of Anthropology.

1949, 1970 Roland F. Dickey. *New Mexico Village Arts.* Albuquerque: University of New Mexico Press.

1960, 1967 José E. Espinosa. *Saints in the Valleys.* Albuquerque: University of New Mexico Press.

1967 George Mills. *The People of the Saints.* Colorado Springs: Taylor Museum.

1967 Robert Shalkop. *Wooden Saints.* Colorado Springs: Taylor Museum.

1968, 1986 Richard E. Ahlborn. *The Pentitente Moradas of Abiquiú.* Washington: Smithsonian.

1971 Robert Stroessner. *Saints of the Southwest.* Denver: Denver Art Museum.

1974 E. Boyd. *Popular Arts of Spanish New Mexico.* Santa Fe: Museum of New Mexico Press.

1974, 1982 Thomas J. Steele, S.J. *Santos and Saints.* Albuquerque: Calvin Horn Publisher; Santa Fe: Ancient City Press.

1976, 1990 Marta Weigle. *Brothers of Light, Brothers of Blood.* Albuquerque: University of New Mexico Press.

1977 William Wroth. *Hispanic Crafts of the Southwest.* Colorado Springs: Taylor Museum.

1979 William Wroth. *The Chapel of Our Lady of Talpa.* Colorado Springs: Taylor Museum.

1980 Charles L. Briggs. *The Wood Carvers of Córdova, New Mexico.* Knoxville: University of Tennessee Press.

1981 William Wroth. *Christian Images of Hispanic New Mexico.* Colorado Springs: Taylor Museum.

1983 Christine Mather. *Colonial Frontiers: The Fred Harvey Collection.* Sante Fe: Ancient City Press.

1985 Thomas J. Steele, S.J. and Rowena Rivera. *Pentitente Self-Government.* Santa Fe: Ancient City Press.

1986 Charles C. Eldredge, et al. *Art in New Mexico, 1900-1945: Paths to Taos and Santa Fe.* New York: Abbeyville Press.

1990 Lane Coulter and Maurice Dixon, Jr. *New Mexican Tinwork, 1840-1940.* Albuquerque: University of New Mexico Press.

RU 221. Nuestra Señora de Guadalupe. Print. 33.6 x 16.5. Louie Ewing. 1941.

1991 William Wroth. *Images of Penance, Images of Mercy*. Norman: University of Oklahoma Press.

1992 Larry Frank. *New Kingdom of the Saints*. Santa Fe: Red Crane Books.

1994 Robin Farwell Gavin. *Traditional Arts of Spanish New Mexico*. Santa Fe: Museum of New Mexico Press.

1994 Laurie Beth Kalb. *Crafting Devotions*. Albuquerque: University of New Mexico Press.

1994 Thomas J. Steele, S.J. *Santos and Saints: The Religious Folk Art of Hispanic New Mexico*. (revised). Santa Fe: Ancient City Press.

1995 Barbe Awalt and Paul Rhetts. *Charlie Carrillo: Tradition and Soul*. Albuquerque: LPD Press.

1995 MariLyn C. Salvador. *Cuando Hablan los Santos*. Albuquerque: Maxwell Museum of Anthropology.

1996 Edward Gonzales and David Witt. *Spirit Ascendant: The Art and Life of Patrociño Barela*. Santa Fe: Red Crane Books.

1996 Donna Pierce and Marta Weigle. *Spanish New Mexico: The Spanish Colonial Arts Society Collection*. Santa Fe: Museum of New Mexico Press.

1997 Barbe Awalt and Paul Rhetts. *Our Saints Among Us/Nuestros Santos Entre Nosotros: 400 Years of New Mexican Devotional Art*. Albuquerque: LPD Press (Fall 1997).

The Wider Background

1974 Gloria Fraser Giffords. *Mexican Folk Retablos*. Tucson: University of Arizona Press.

1983 Marta Weigle, et. al, eds. *Hispanic Arts and Ethnohistory*. Santa Fe: Ancient City Press.

1990 Rosa María Sánchez Lara. *Los retablos populares Exvotos pintados*. México: UNAM Instituto de Investigaciones Estéticas.

1991 Gloria Fraser Giffords. *The Art of Private Devotion: Retablo Painting in Mexico*. Fort Worth: Intercultura.

1992 Gloria Fraser Giffords. *Mexican Folk Retablos* (revised). Albuquerque: University of New Mexico Press.

1993 Fray Angélico Chávez. *My Penitente Land*. Santa Fe: Museum of New Mexico Press. (original 1974)

1994 Joseph F. Chorpenning, O.S.F.S. *Mexican Devotional Retablos*. Philadelphia: St. Joseph's University Press.

1994 Michael Wallis and Craig Varjabedian. *En Divina Luz*. Albuquerque: University of New Mexico Press.

1996 Joseph F. Chorpenning, O.S.F.S., *The Holy Family As Prototype of the Civilization of Love*. Philadelphia: St. Joseph's University Press.

1997 Charles M. Carrillo, *Hispanic New Mexican Pottery: Evidence of Craft Specialization 1790-1890*. Albuquerque: LPD Press.

About the Author

Father Tom Steele was born and brought up in the St. Louis area (at the wrong end of the Santa Fe Trail). Following high school, he joined the Jesuits in 1951, attended St. Louis University (B.A., M.A., Ph.L., S.T.L.), and was ordained a priest in 1964. He came to Albuquerque in order to earn a doctorate in English and American literature at the University of New Mexico and fell in love first with the *santos* of Hispanic New Mexico and eventually with everything New Mexican except the politics.

He recently retired from the English Department at Regis University in Denver, but he serves as the curator of the Regis collections of santos and Pueblo pottery and teaches New Mexican topics both at Regis and at UNM, living most of the year at Immaculate Conception Parish in Albuquerque. Steele has written many of his published works with co-authors because without them he cannot readily manage the "postmodern" interdisciplinary methodologies needed at the edges of contemporary scholarship.

His hobbies are art, fishing, golf, and ranching, and he claims to be "the best cowboy in Guadalupe County, New Mexico, who will gladly work for nothing — and worth it!"

Other Books/Resources on Hispanic Arts & Culture from LPD Press

Charlie Carrillo: Tradition & Soul / Tradición y Alma
by Barbe Awalt & Paul Rhetts
ISBN 0-9641542-0-X *(soft cover)*

Hispanic New Mexican Pottery: Evidence of Craft Specialization 1790-1890
by Charles M. Carrillo
ISBN 0-9641542-3-4 *(hard cover)*
ISBN 0-9641542-9-3 *(soft cover)*

Our Saints Among Us/Nuestros Santos Entre Nosotros: 400 Years of New Mexican Devotional Art
by Barbe Awalt & Paul Rhetts
ISBN 0-9641542-2-6 *(hard cover)*
ISBN 0-9641542-8-5 *(soft cover)*

Folked! The Drawings of Nicholas Herrera
ISBN 0-9641542-6-9 *(soft cover)*

Santos: Sacred Art of Colorado
ISBN 0-9641542-5-0 *(soft cover)*

Tradición Revista: The Journal of Contemporary & Traditional Spanish Colonial Art & Culture
ISSN 1093-0973 *(quarterly magazine)*